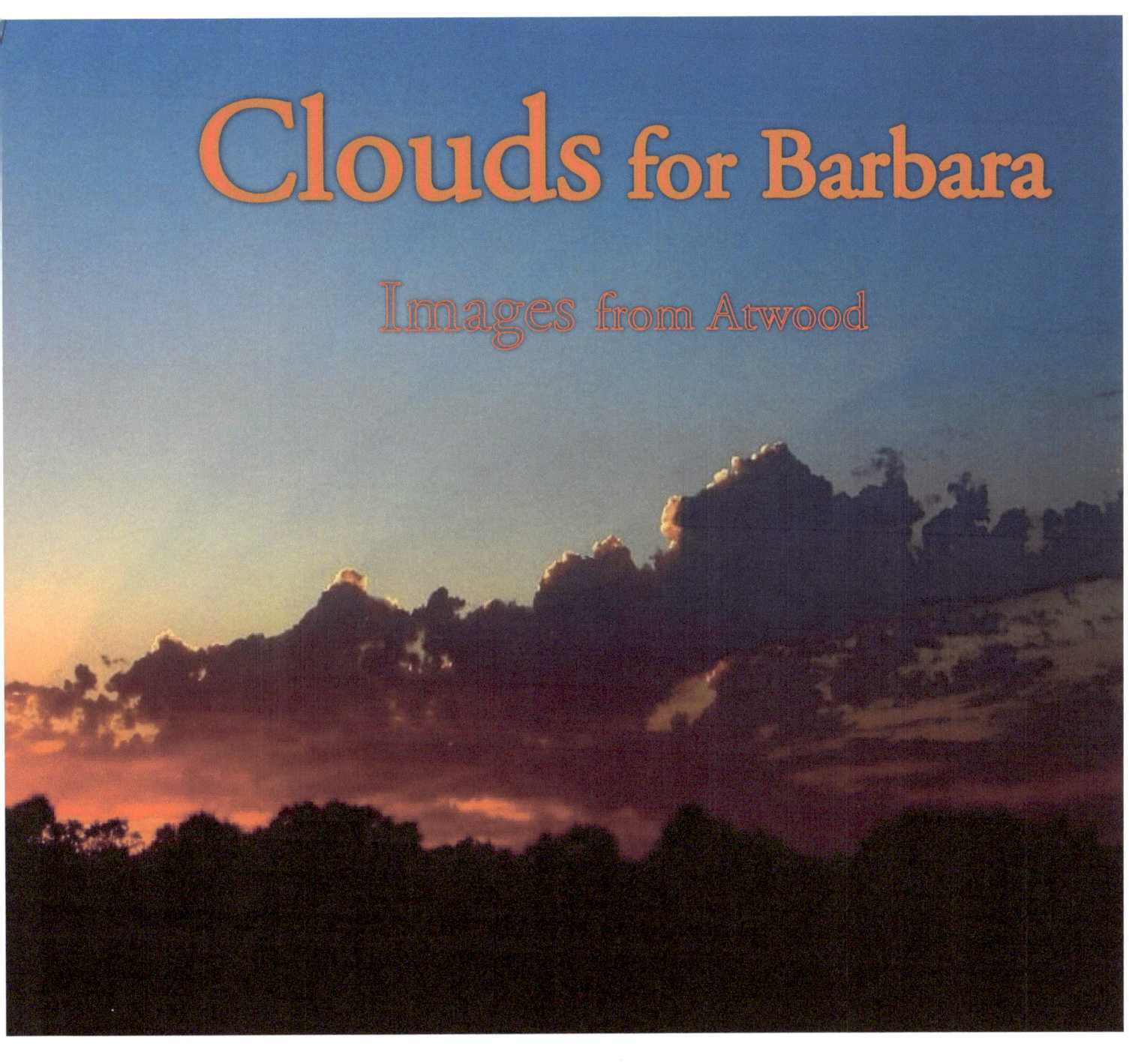

# Clouds for Barbara
## Images from Atwood

Copyright 2015 by Echo Hill Arts Press, LLC.
All rights reserved, including the right to reproduce any or all of these contents.
ISBN: 978-1519435453
ISBN: 1519435452

For Barbara
Thank you for asking to see more of my sky images.
It's always a pleasure.

Echo Hill Arts Press

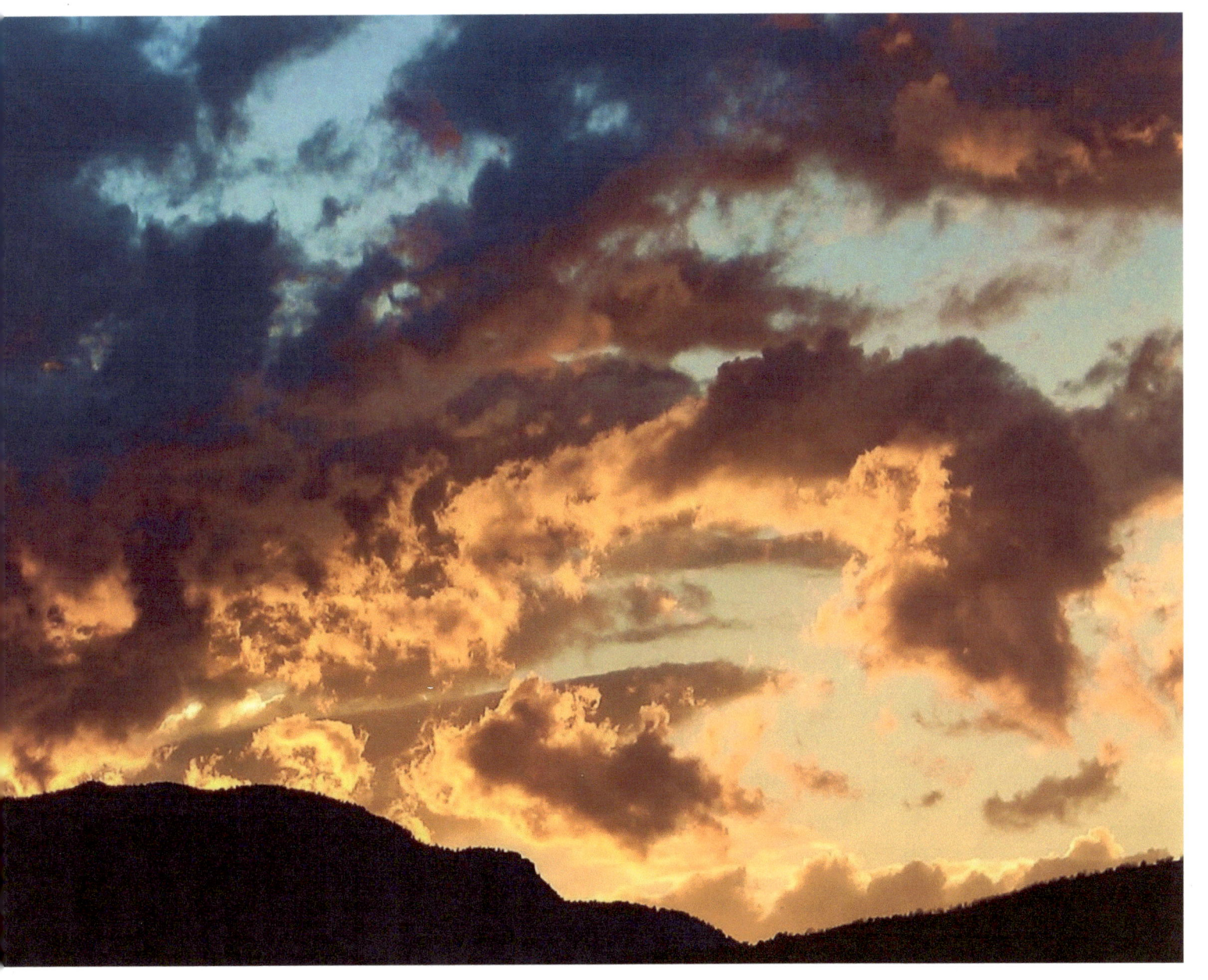

THERE IS POETRY IN THE SKY

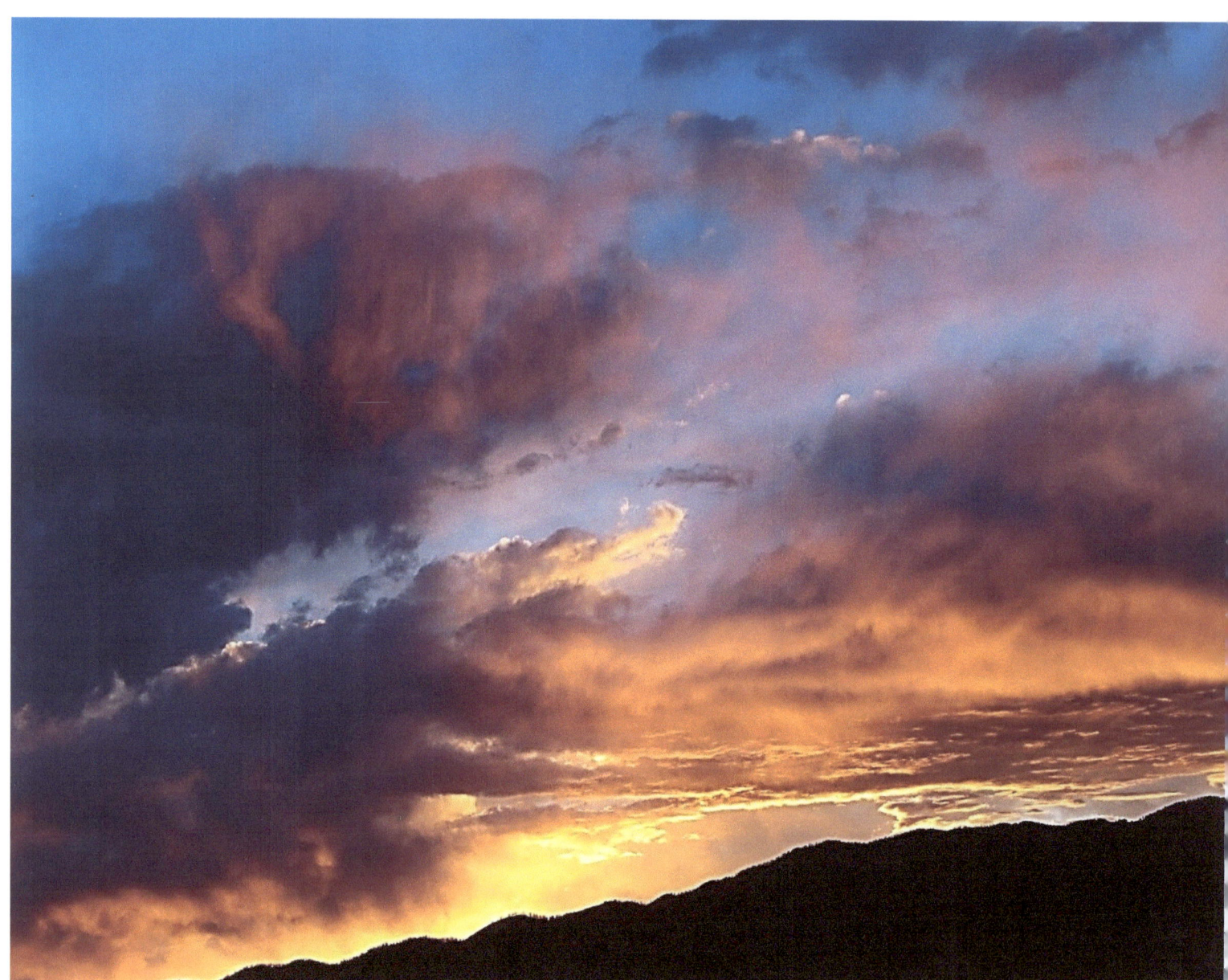

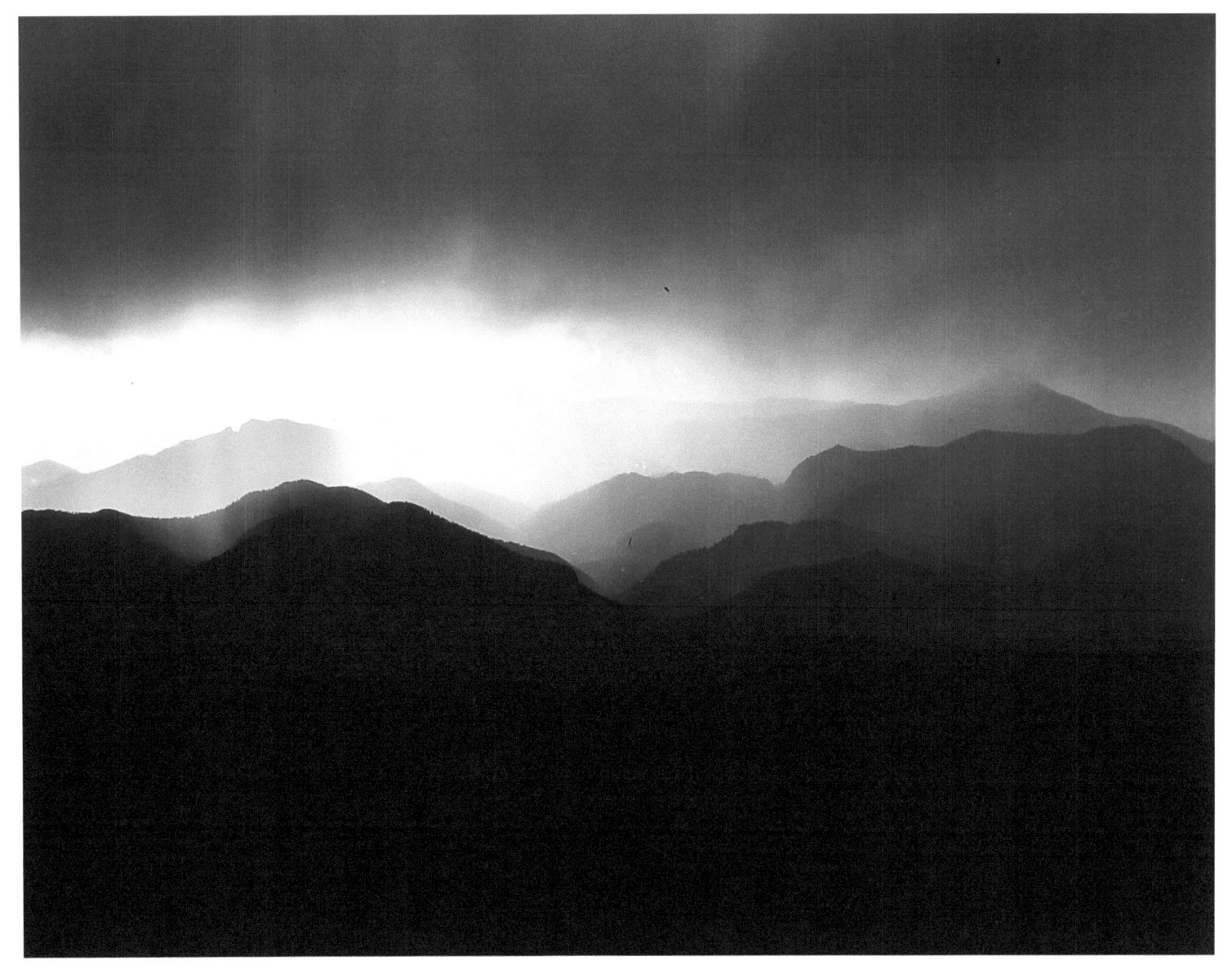

AND IN THE MOUNTAINS

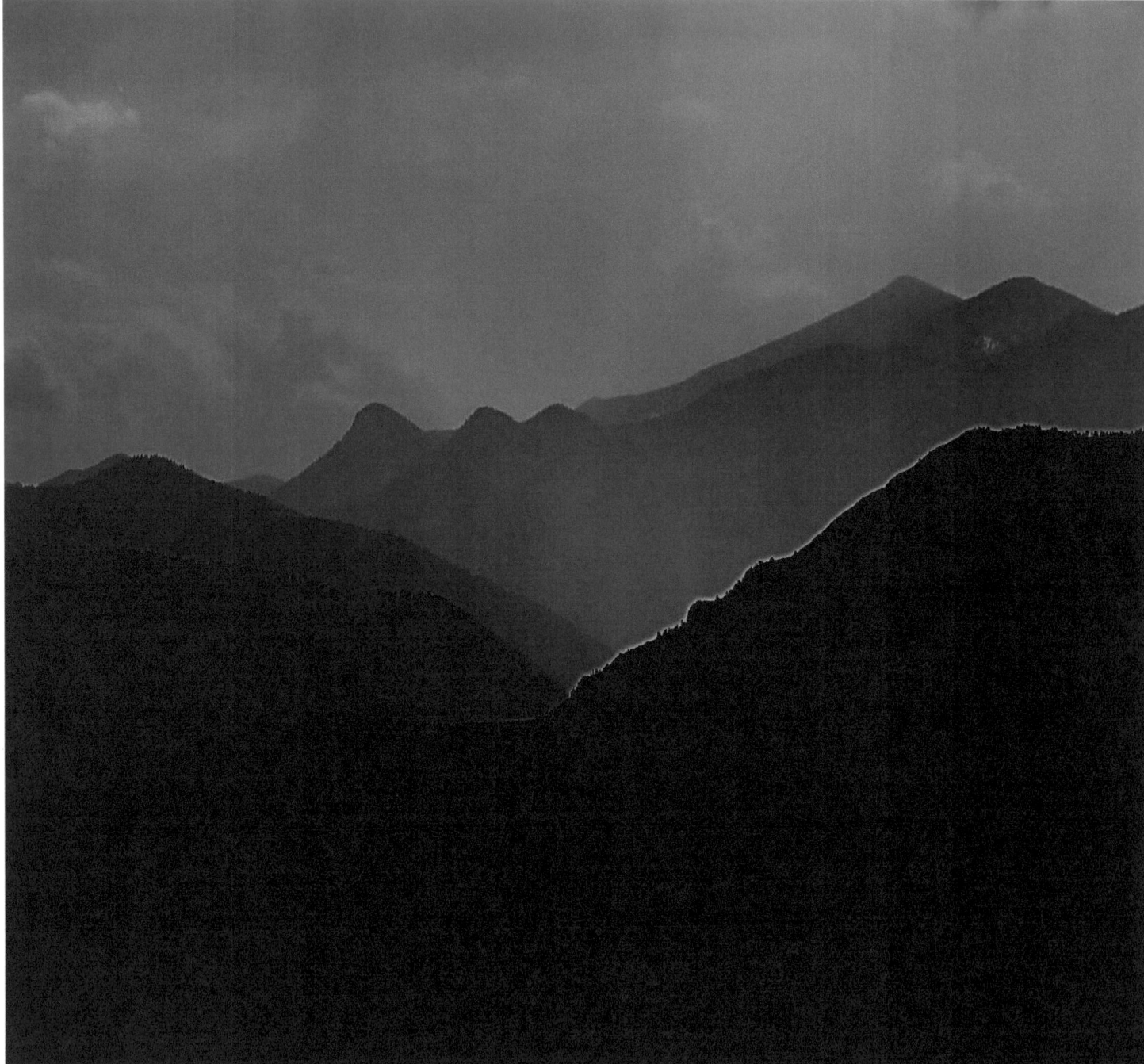

AS WELL AS IN
THE VALLEYS.

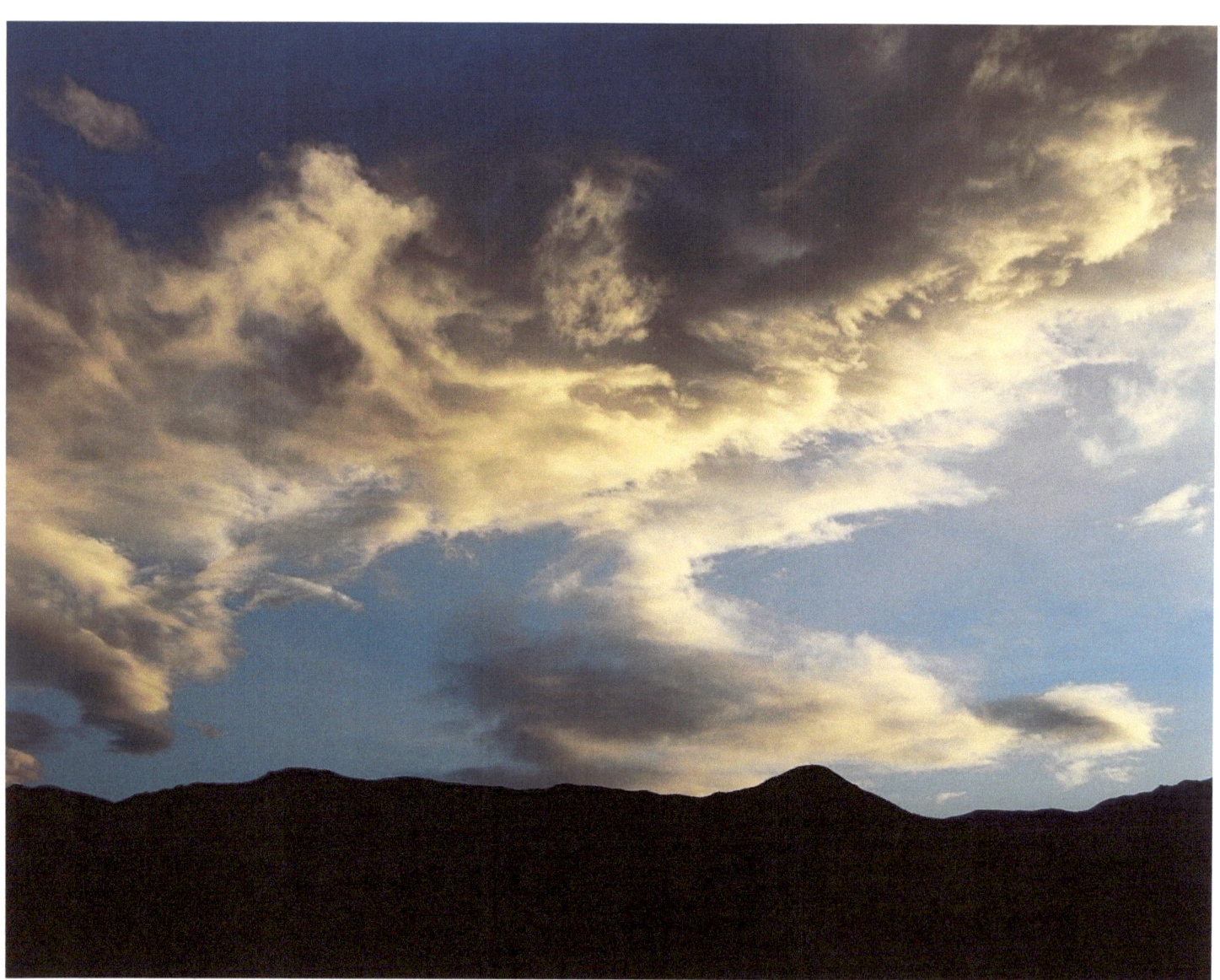

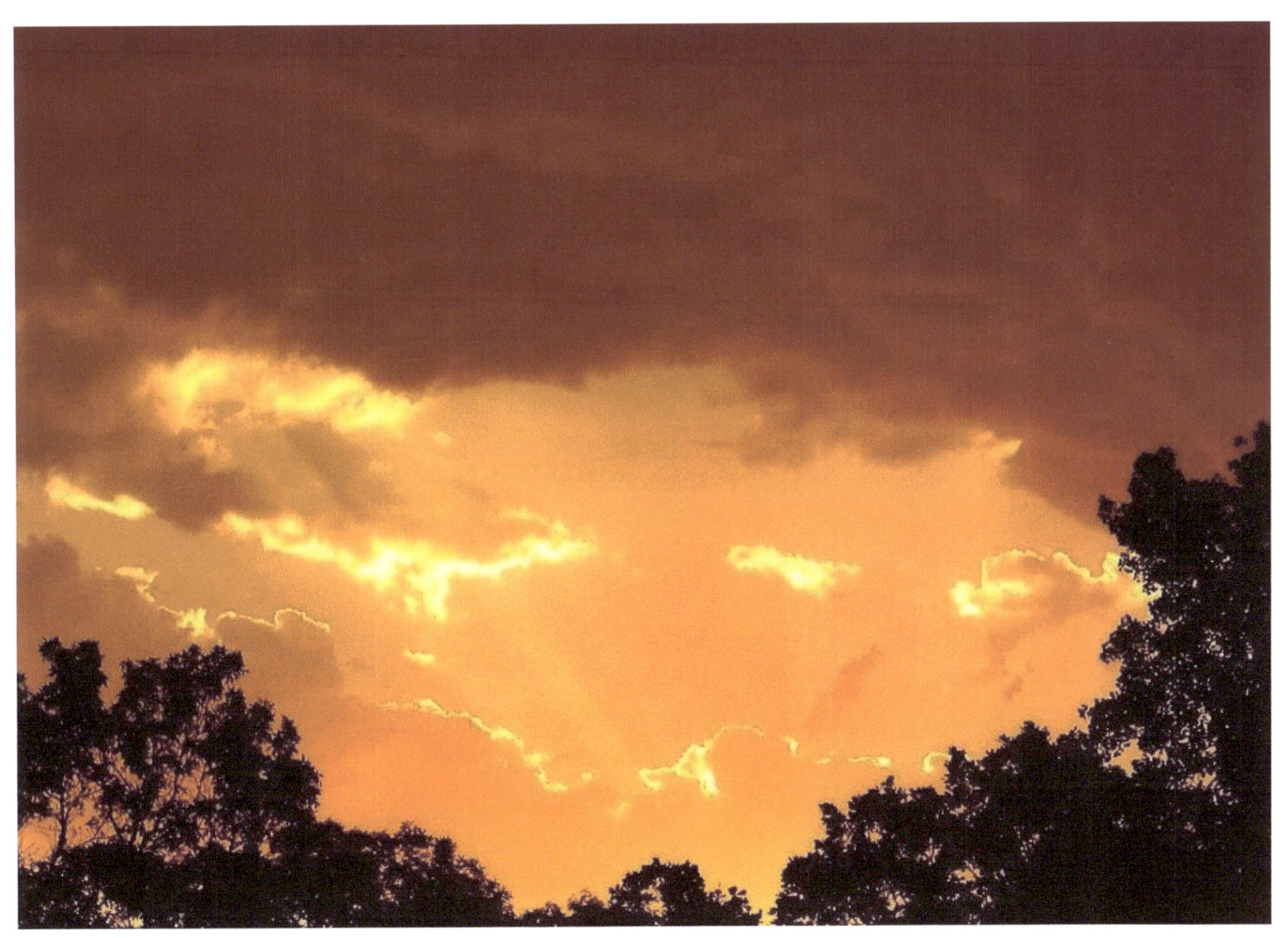

Exuberance

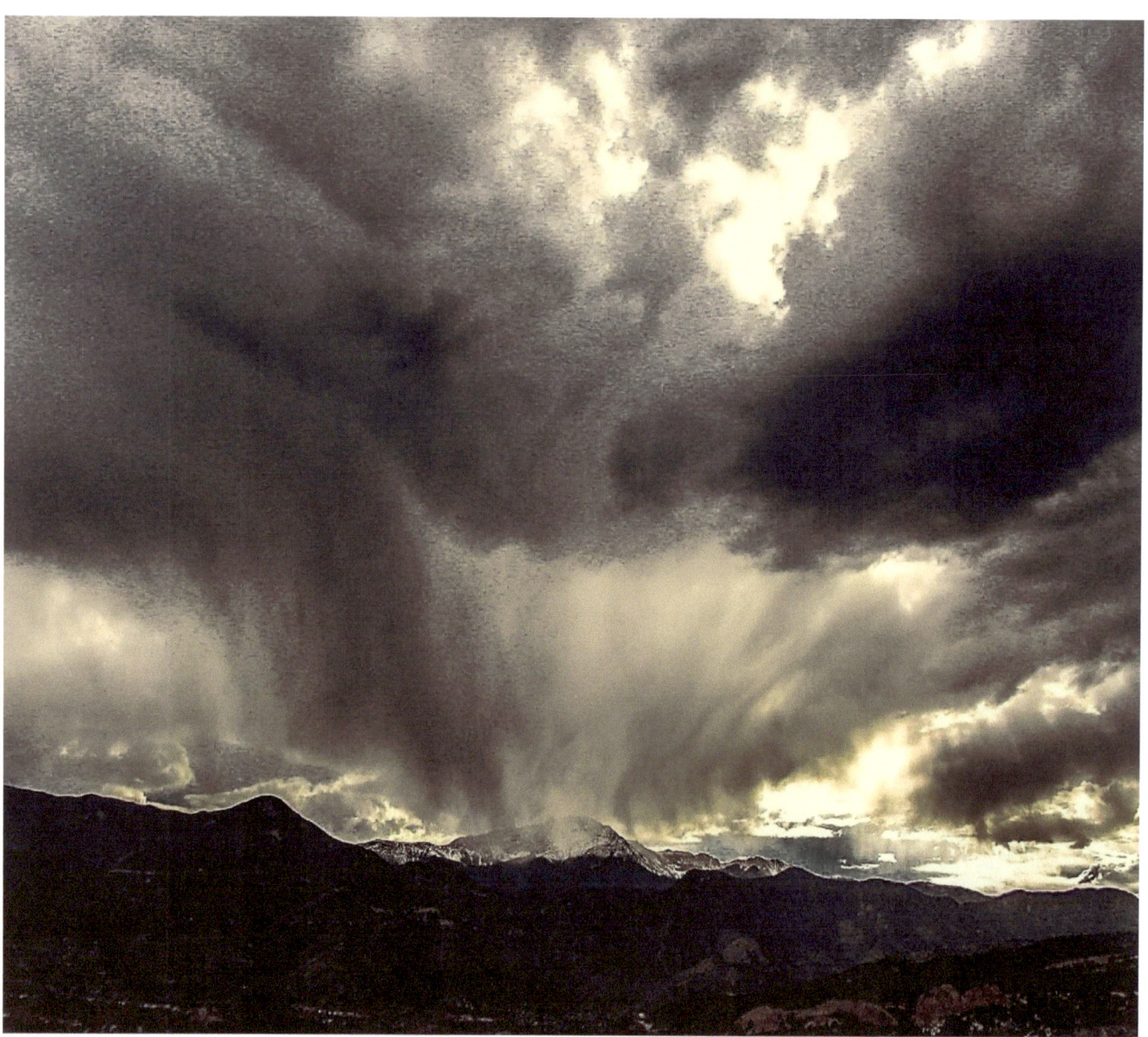

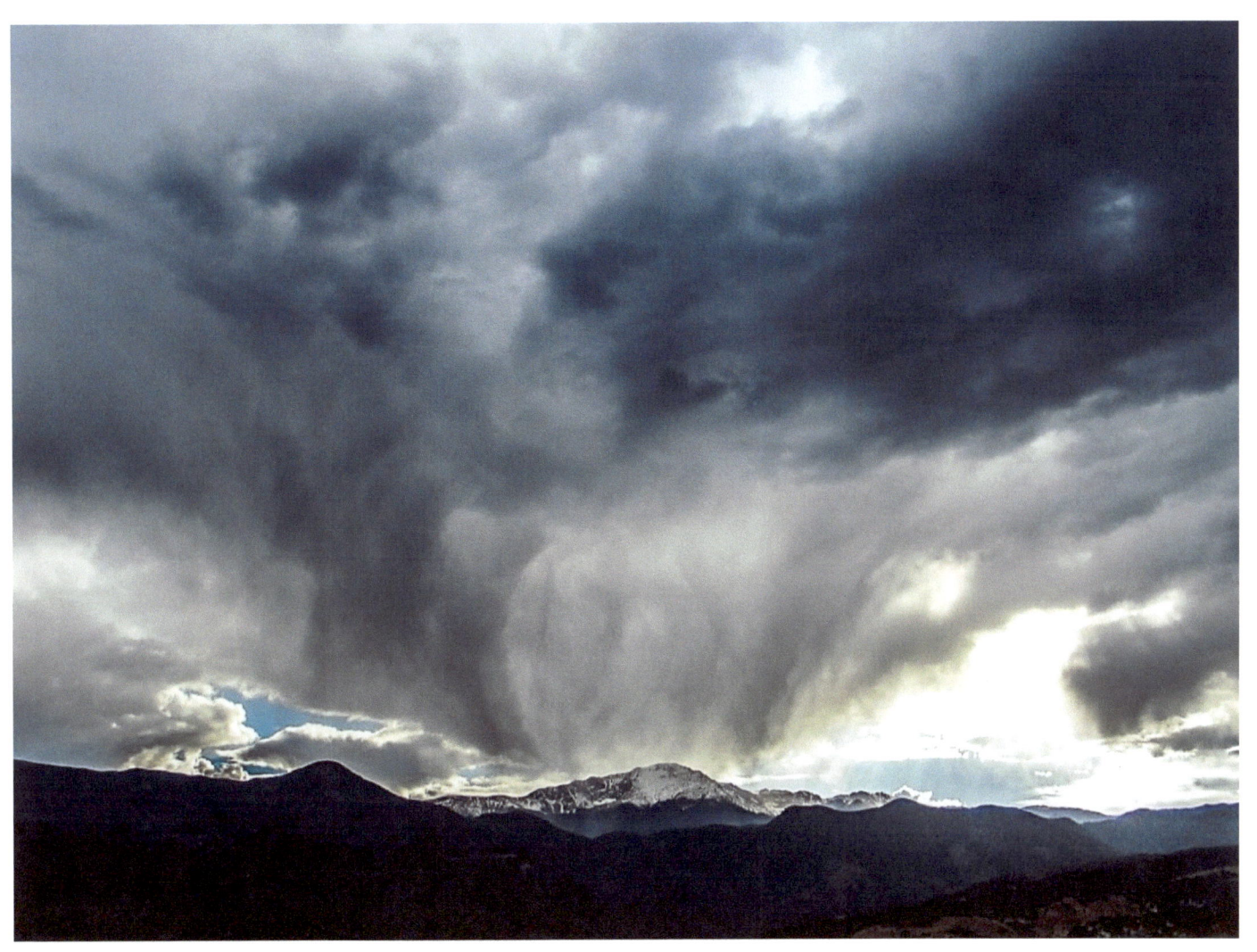

Turbulance

Behold!

the Weathermaker

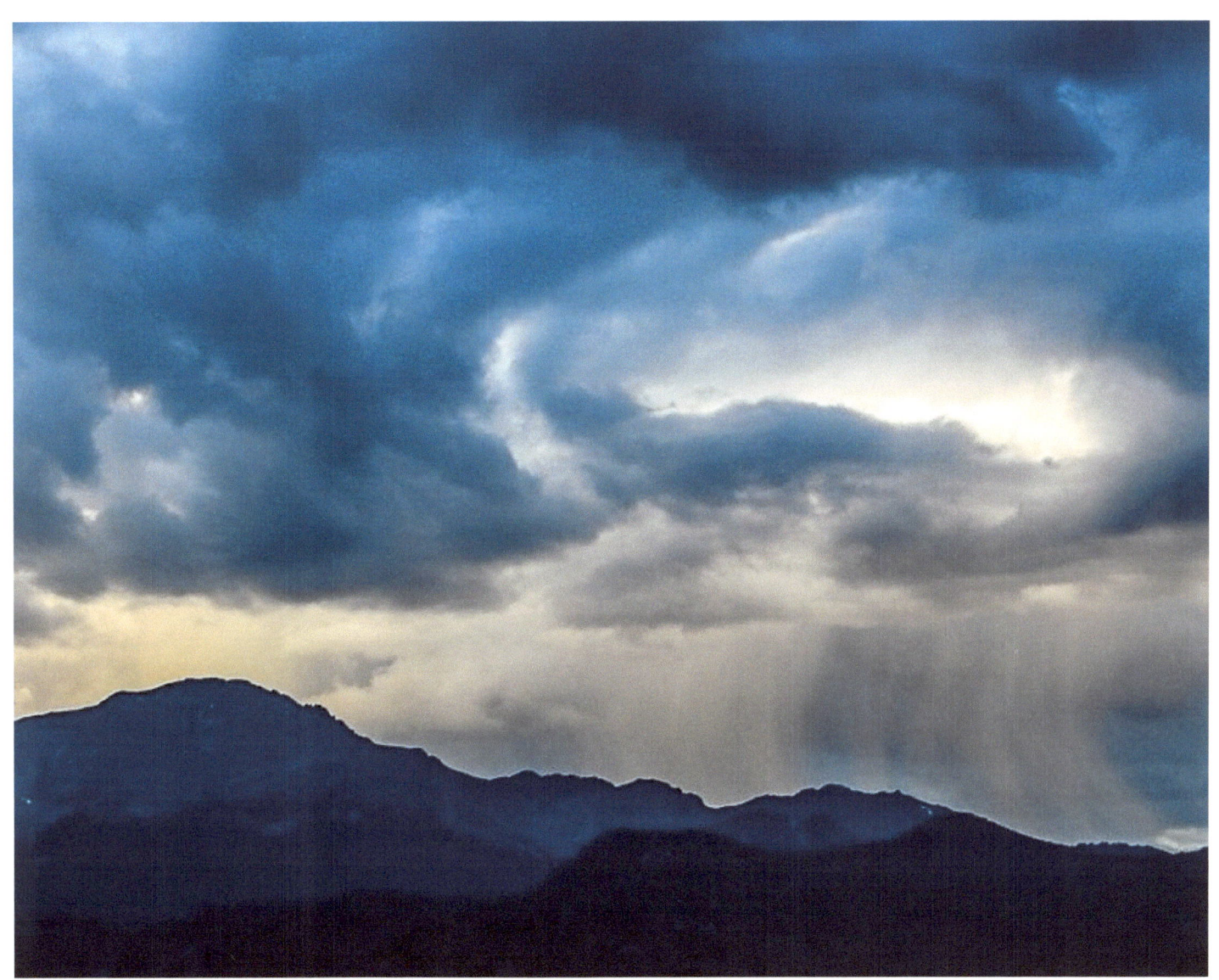

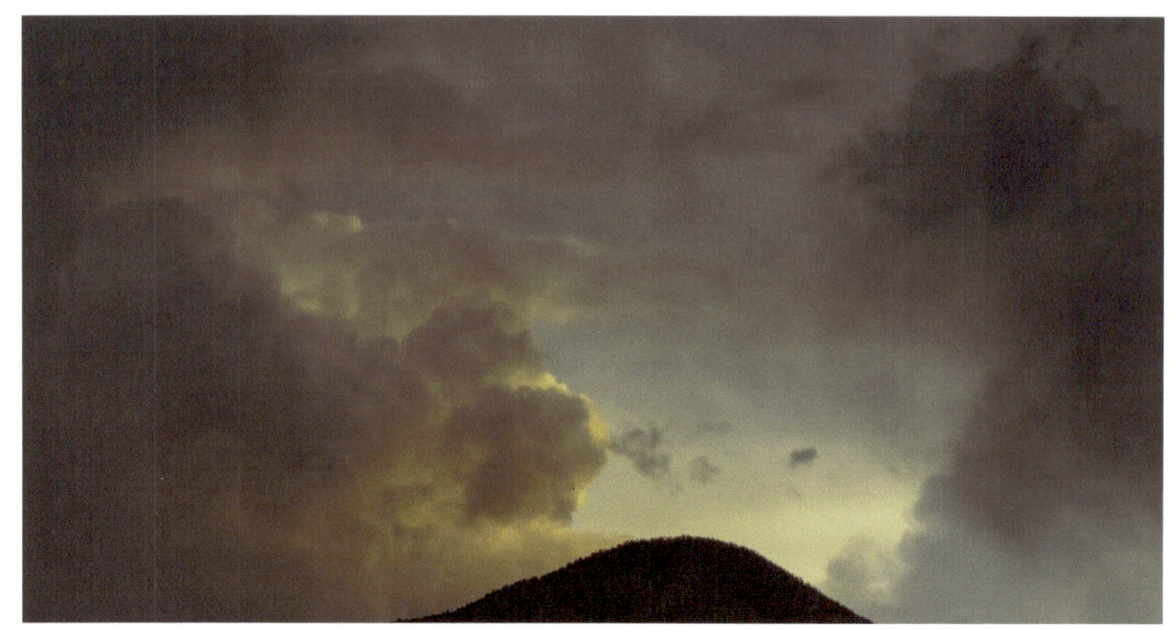

## Feeling the Tao

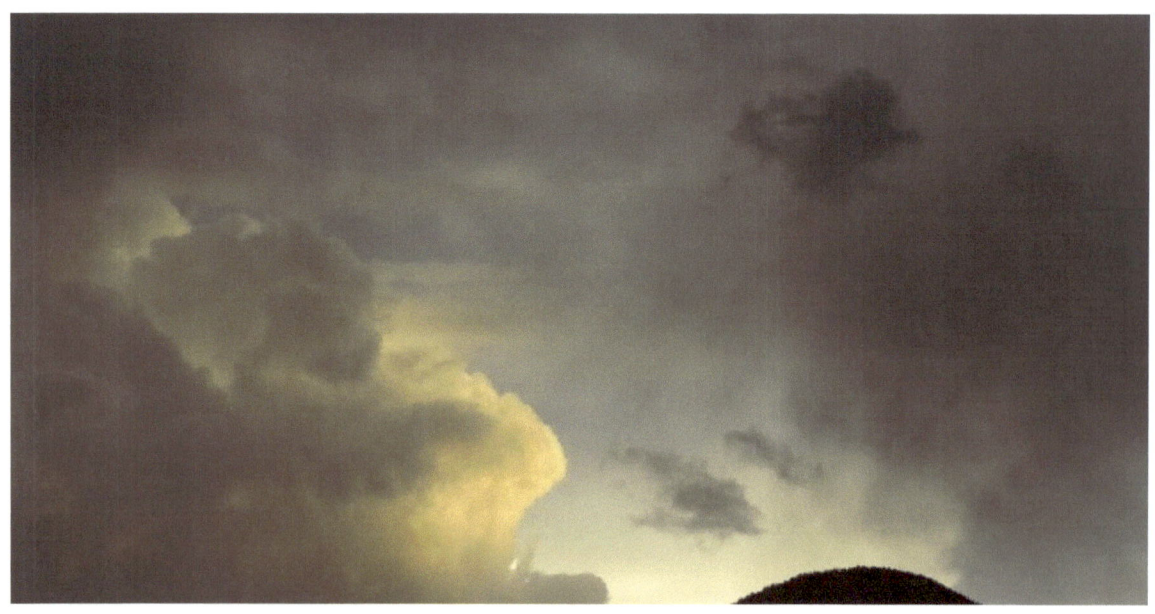

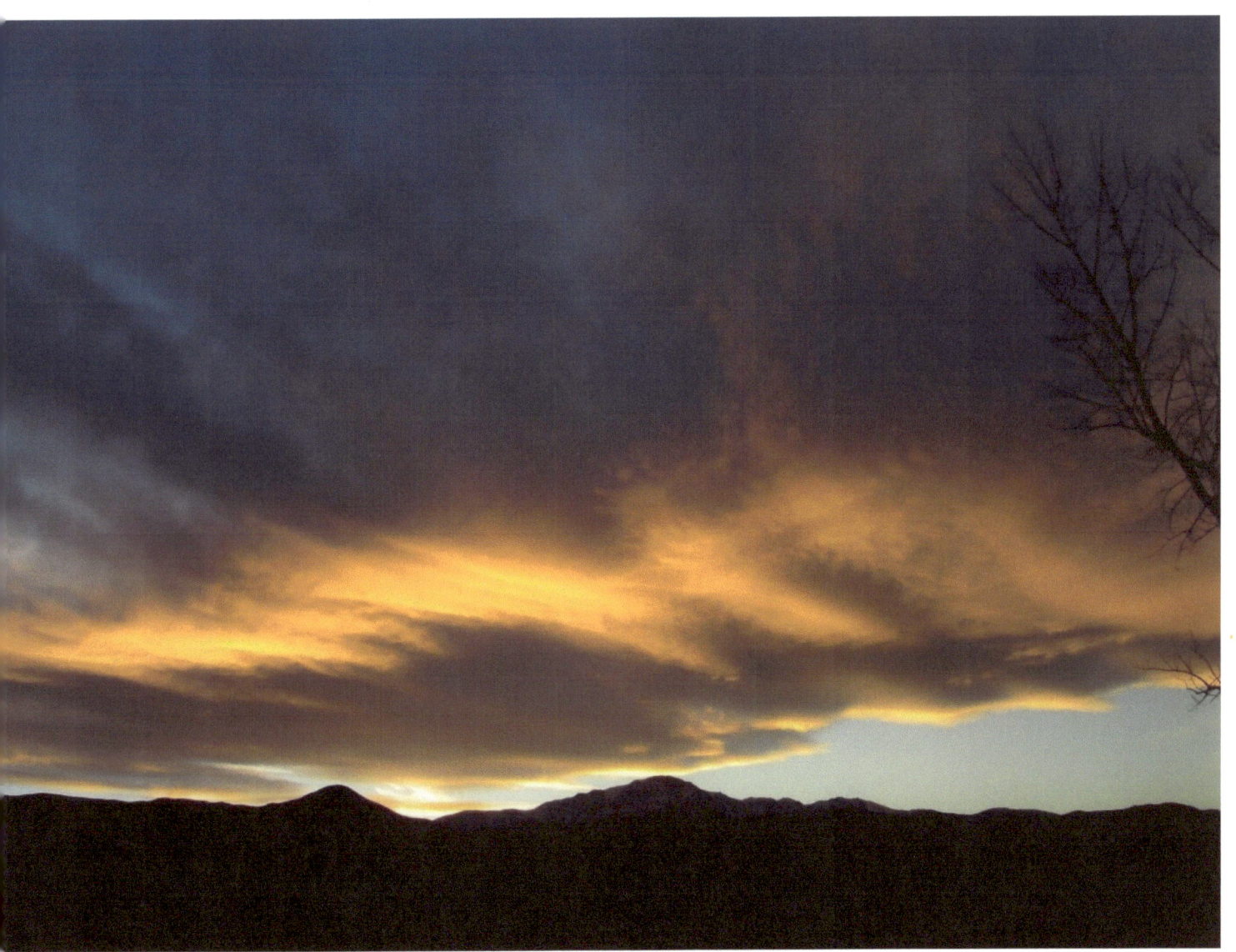

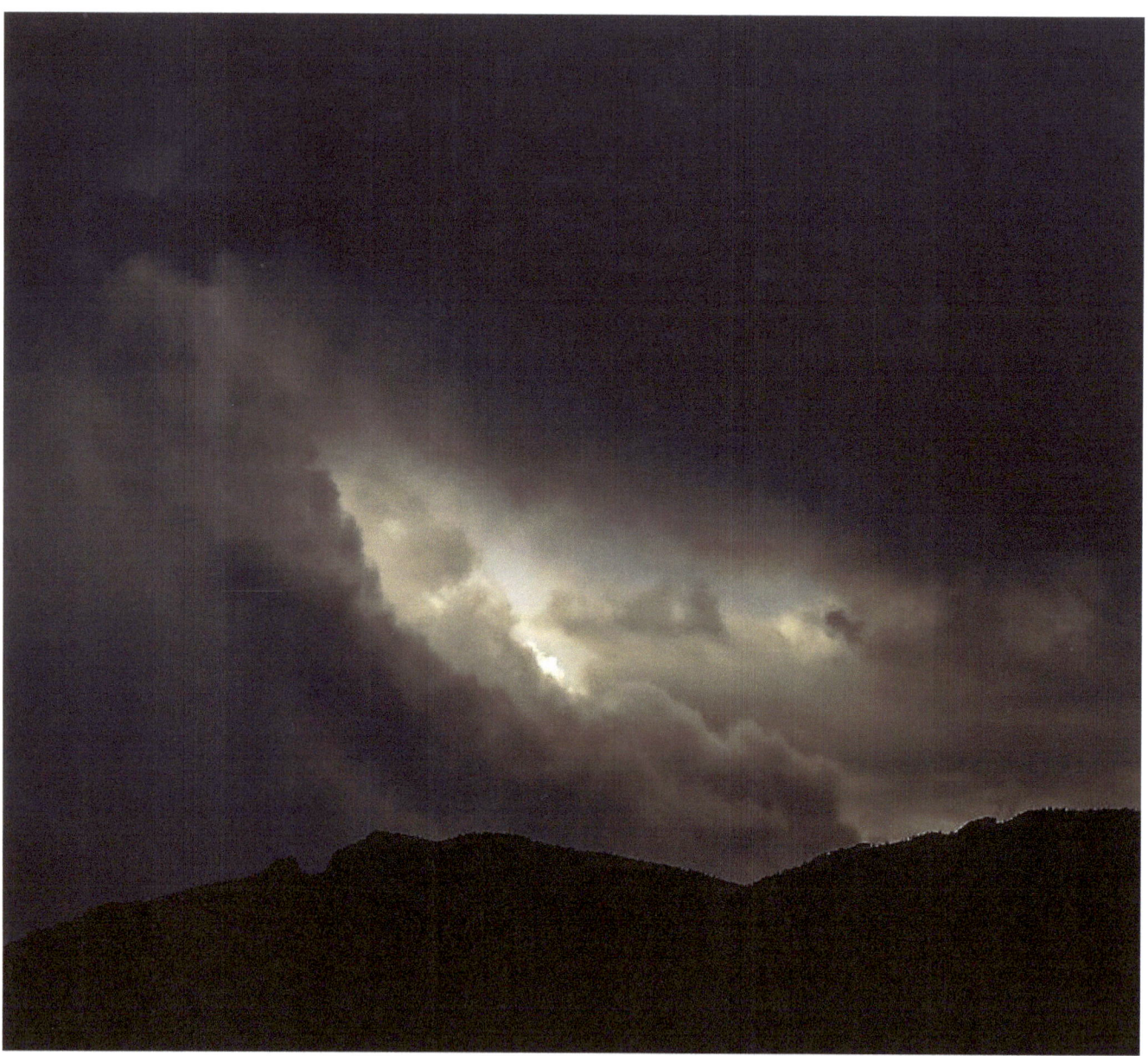

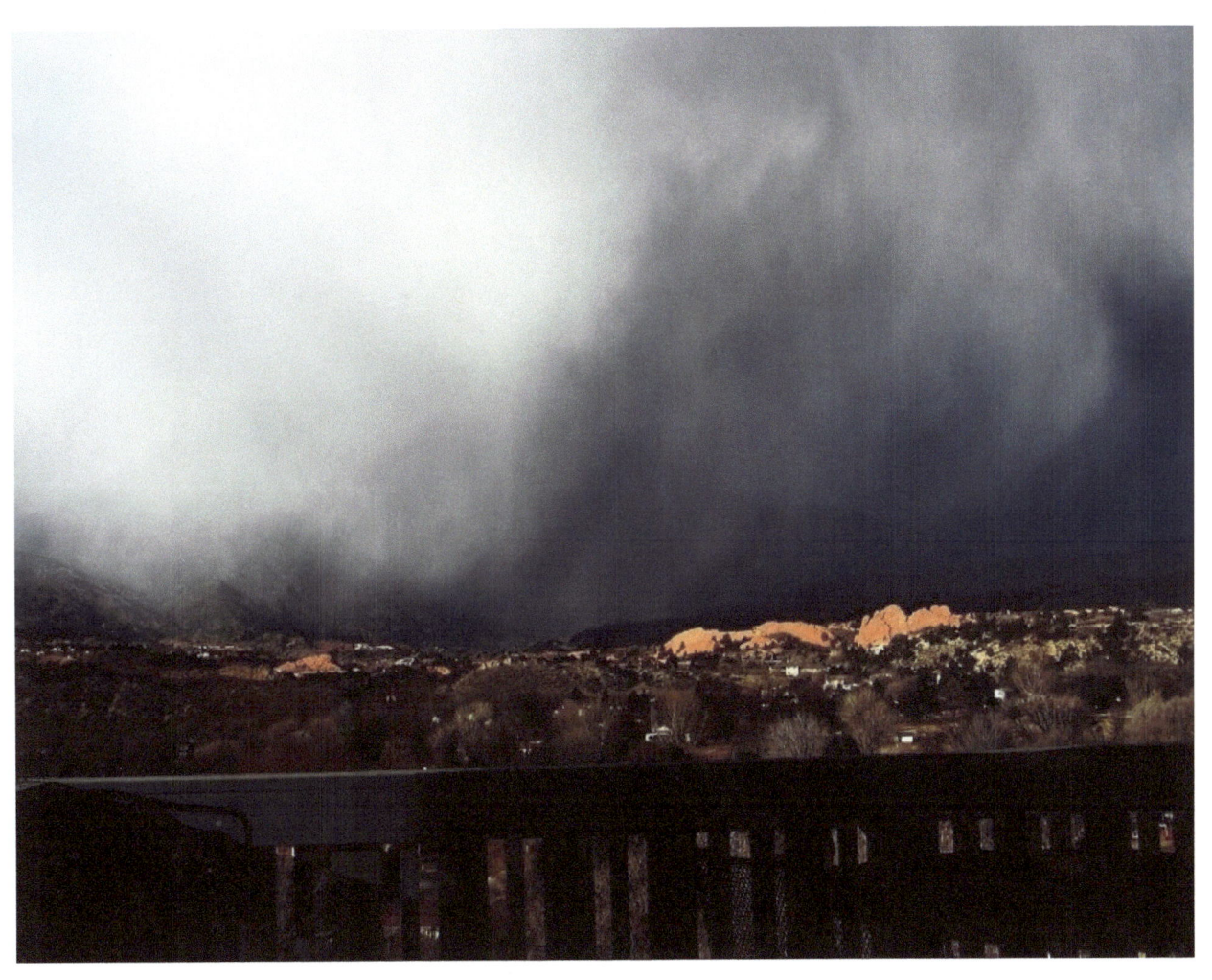

THE YIN AND THE YANG.

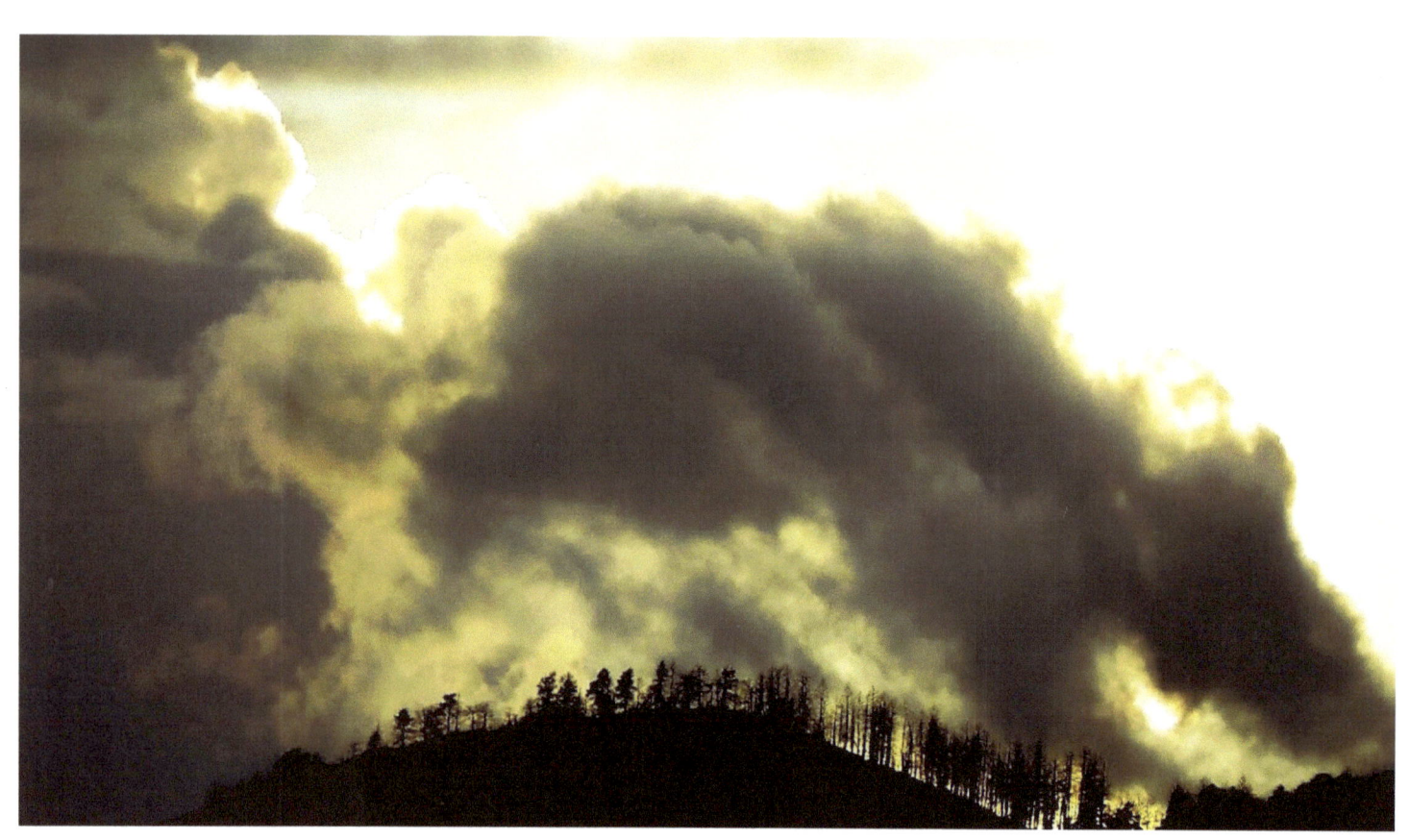

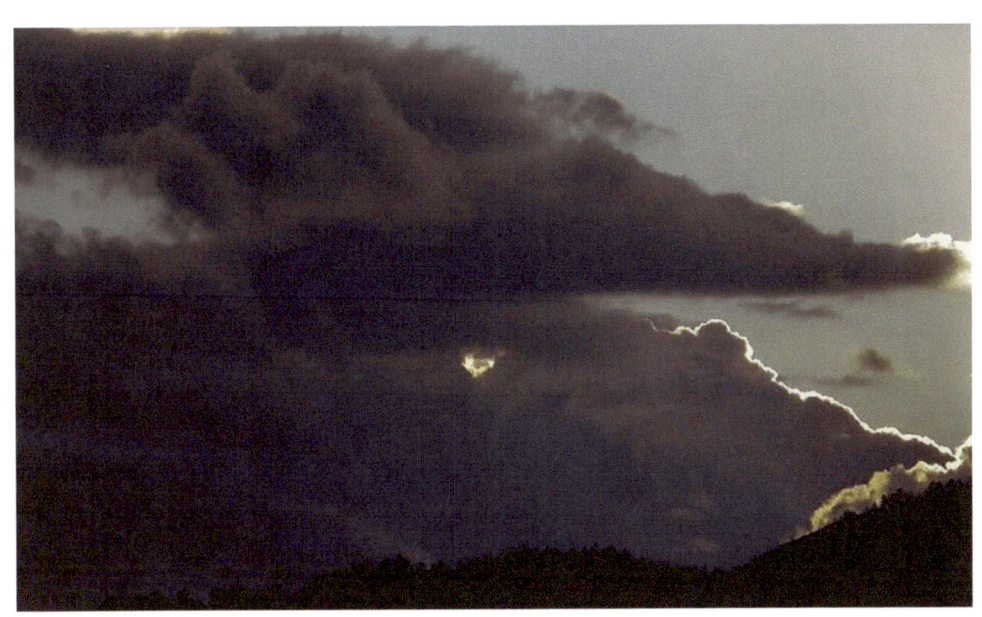 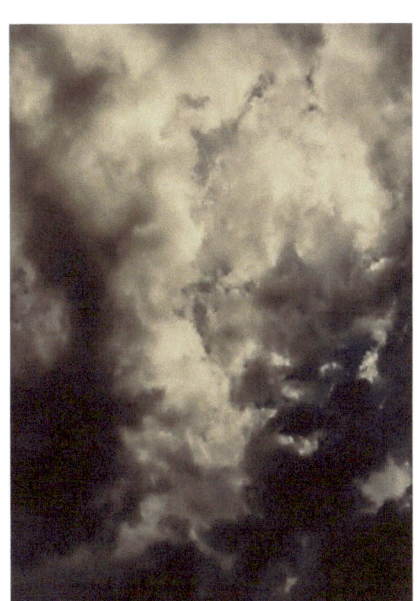

TWO CREATURES FACE OFF

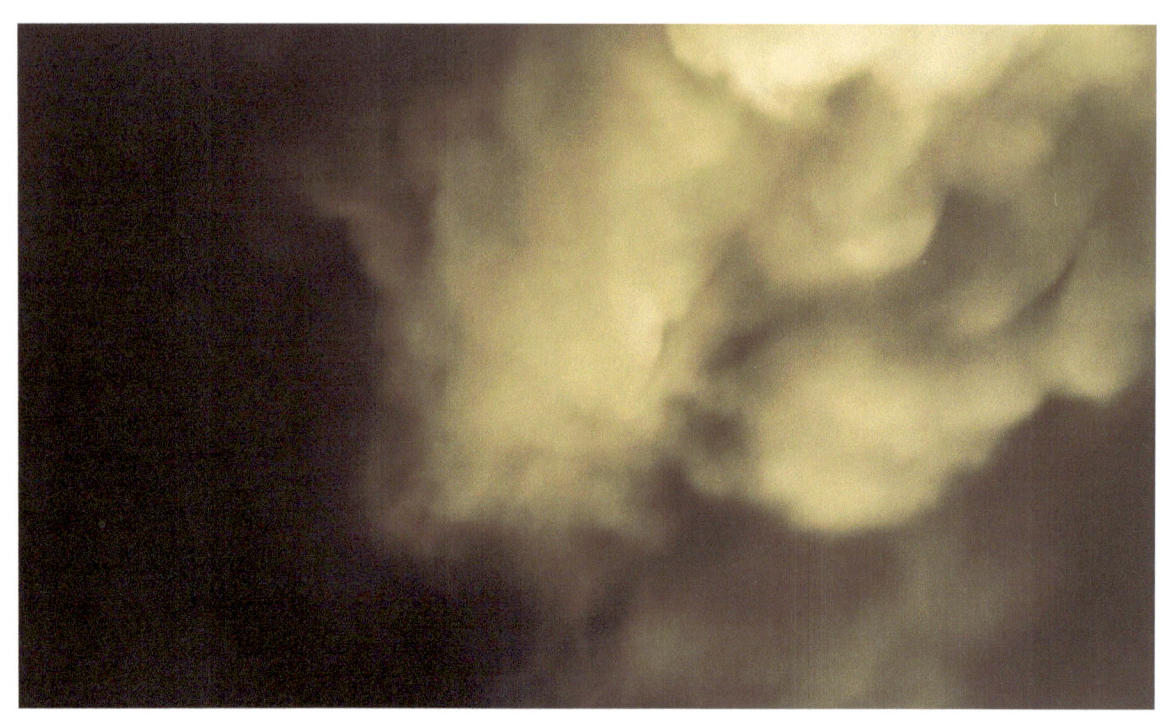

I SEE Popeye

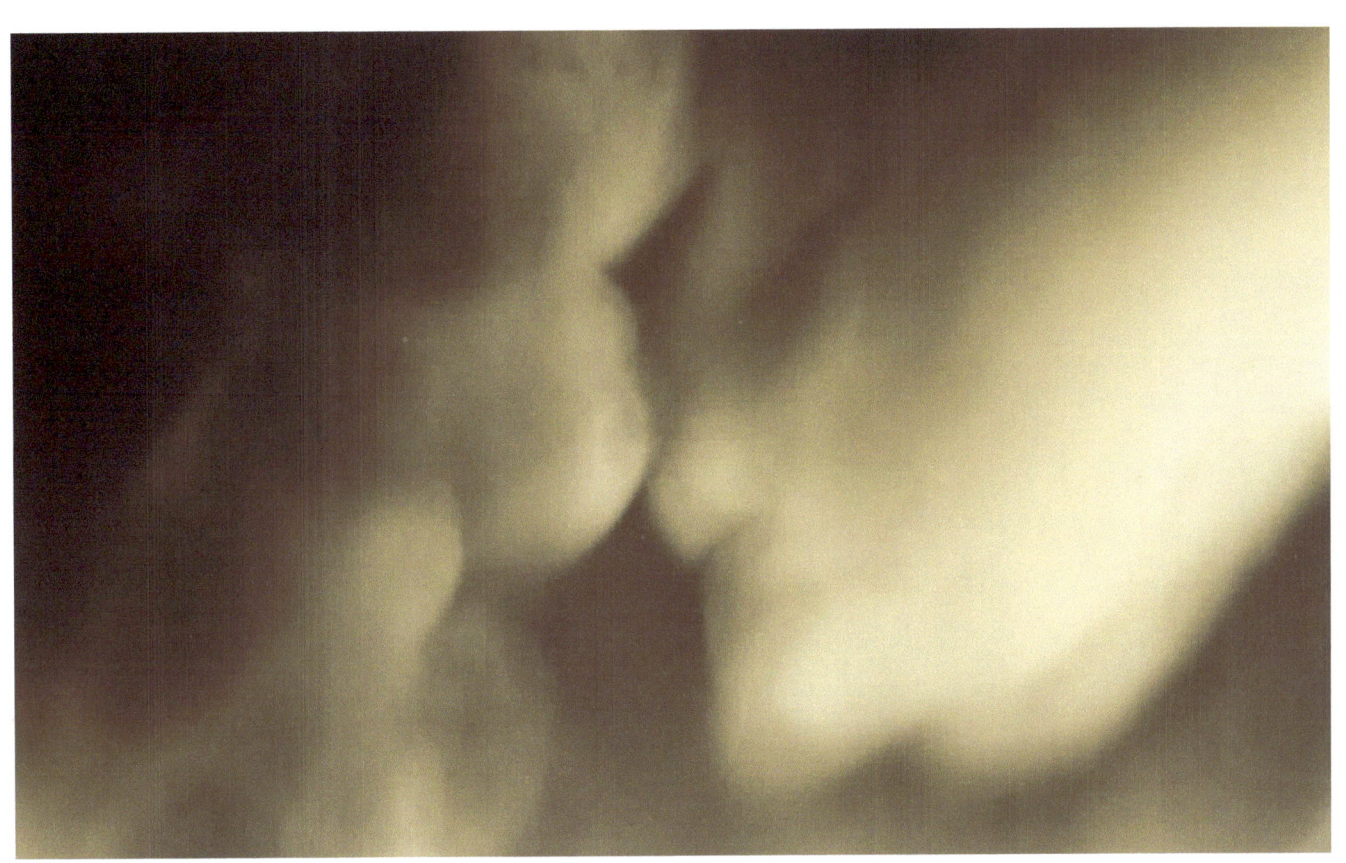

A Kiss

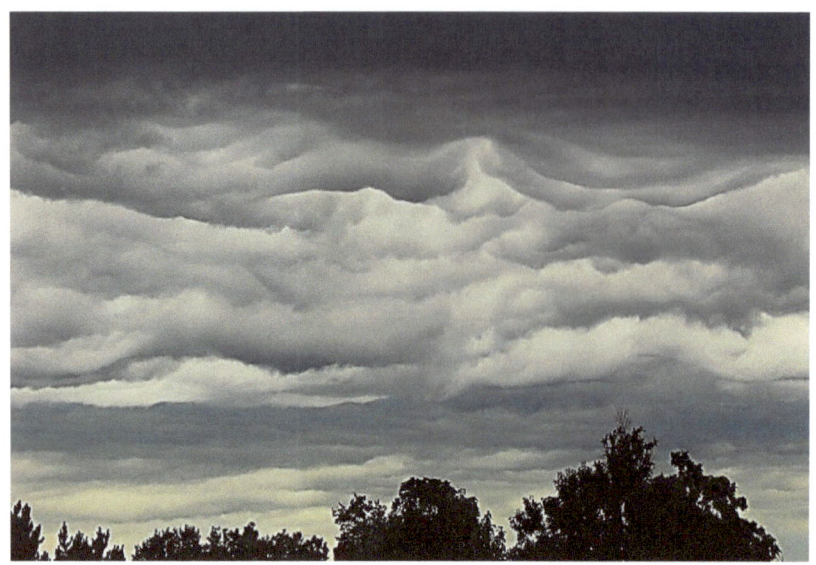
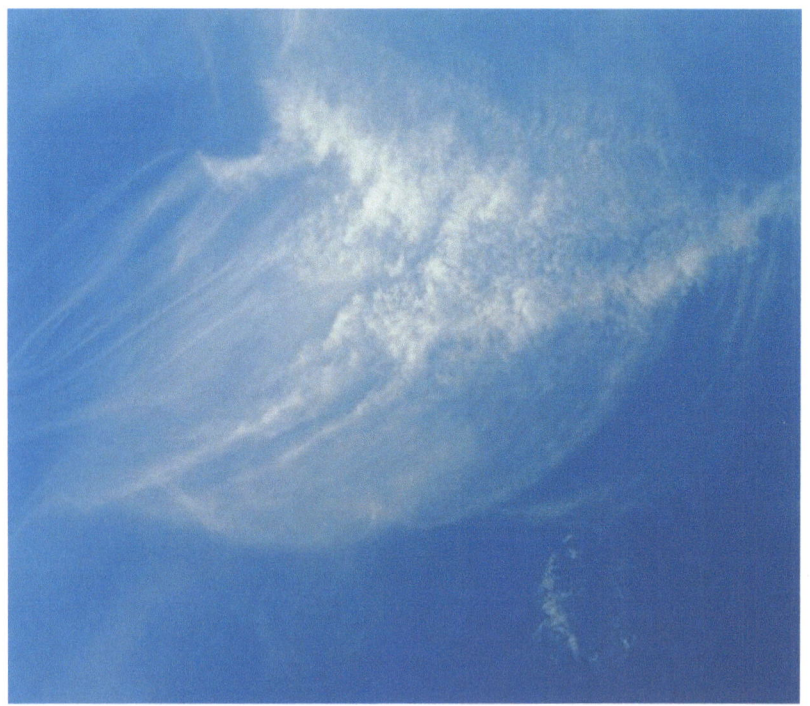
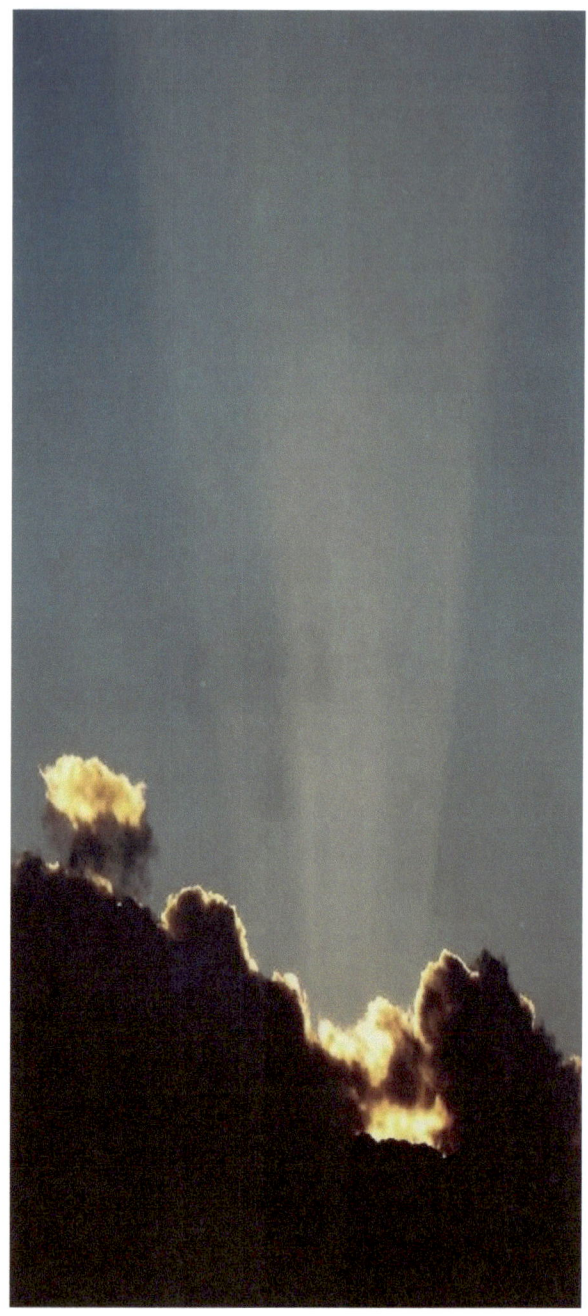

WAVES AND RAYS

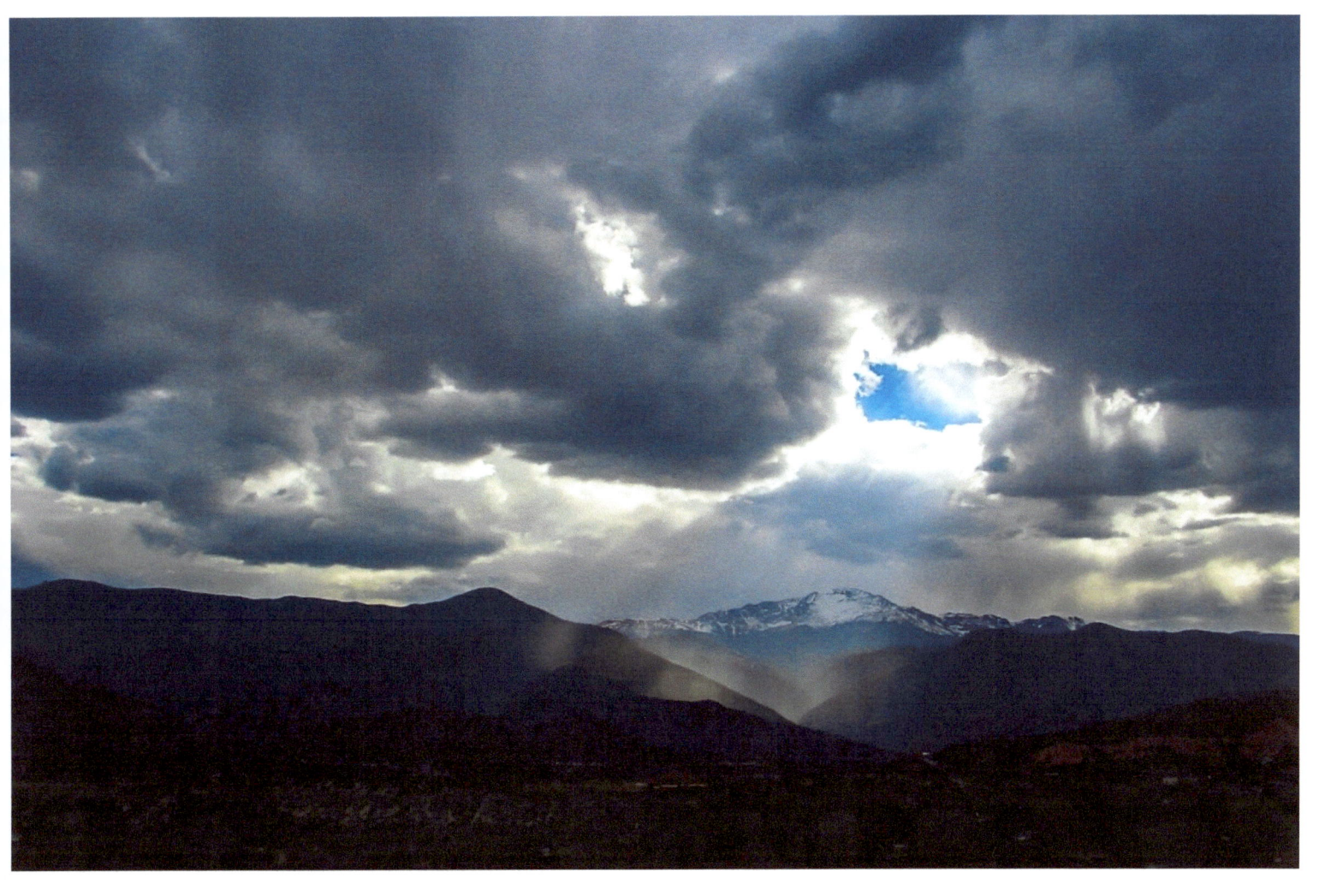

SUNLIGHT ON MANITOU

# Dusk on the plain

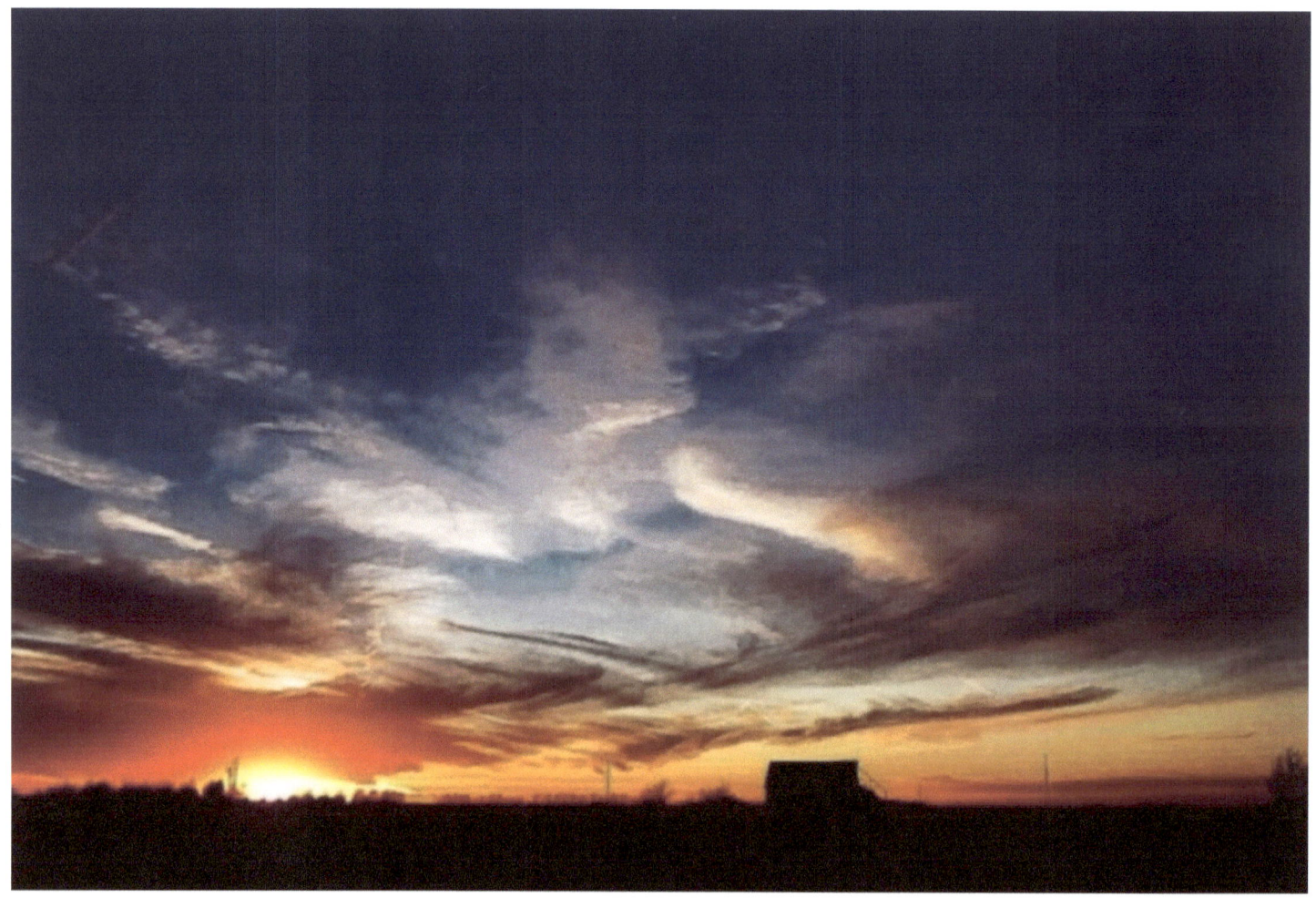

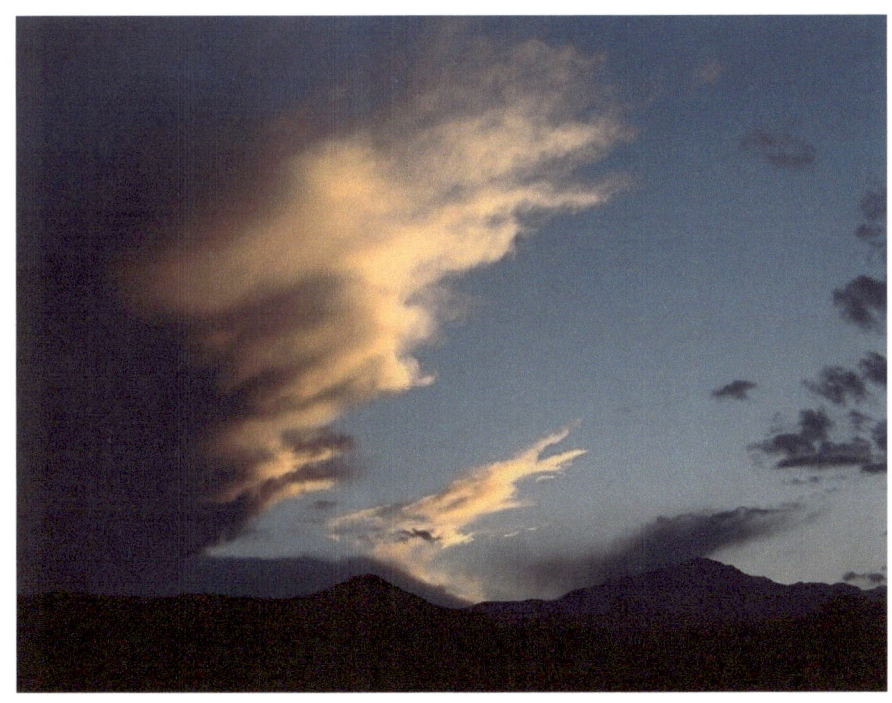

# Wind writing

## This is the Hitchcock series

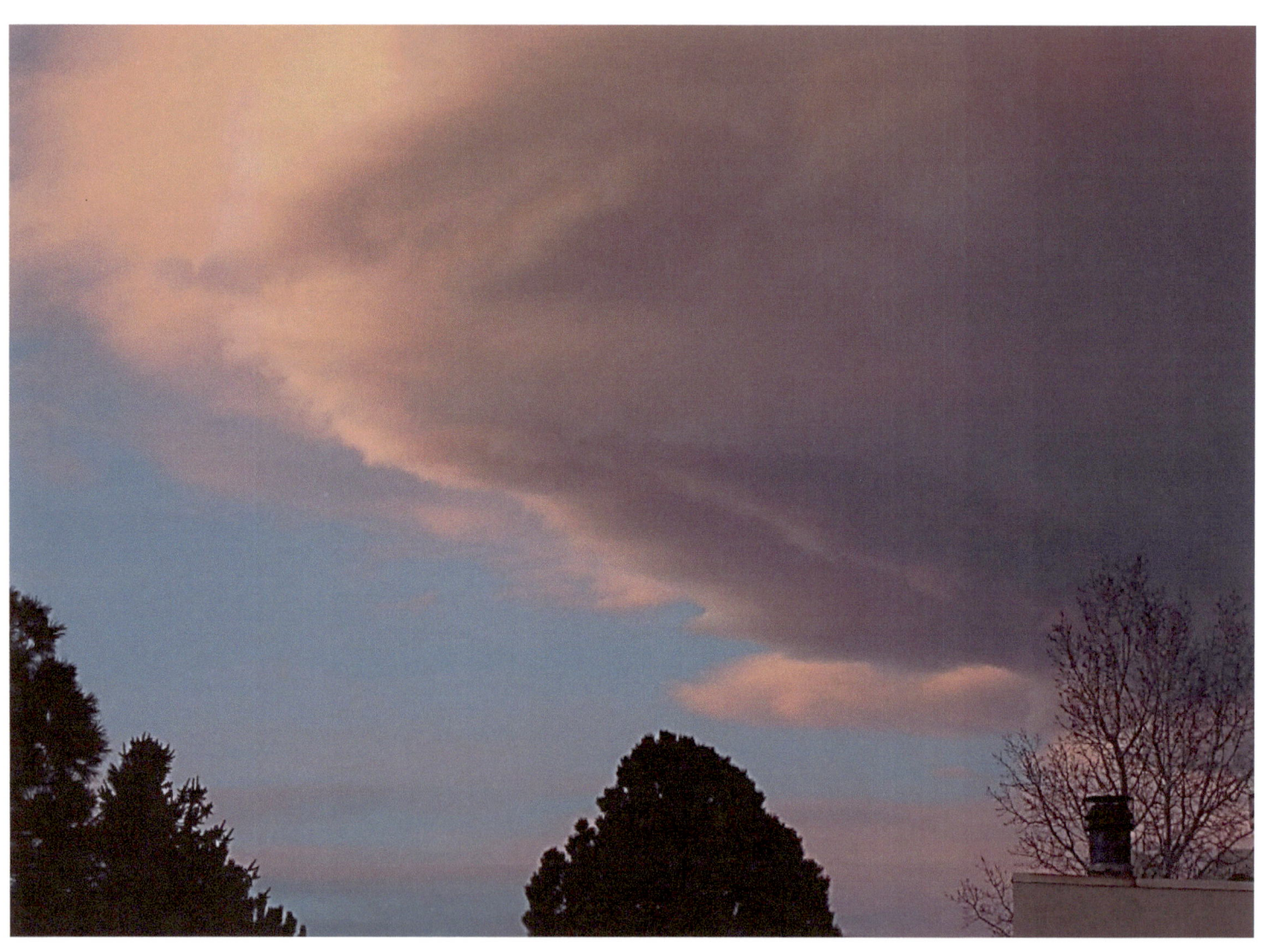

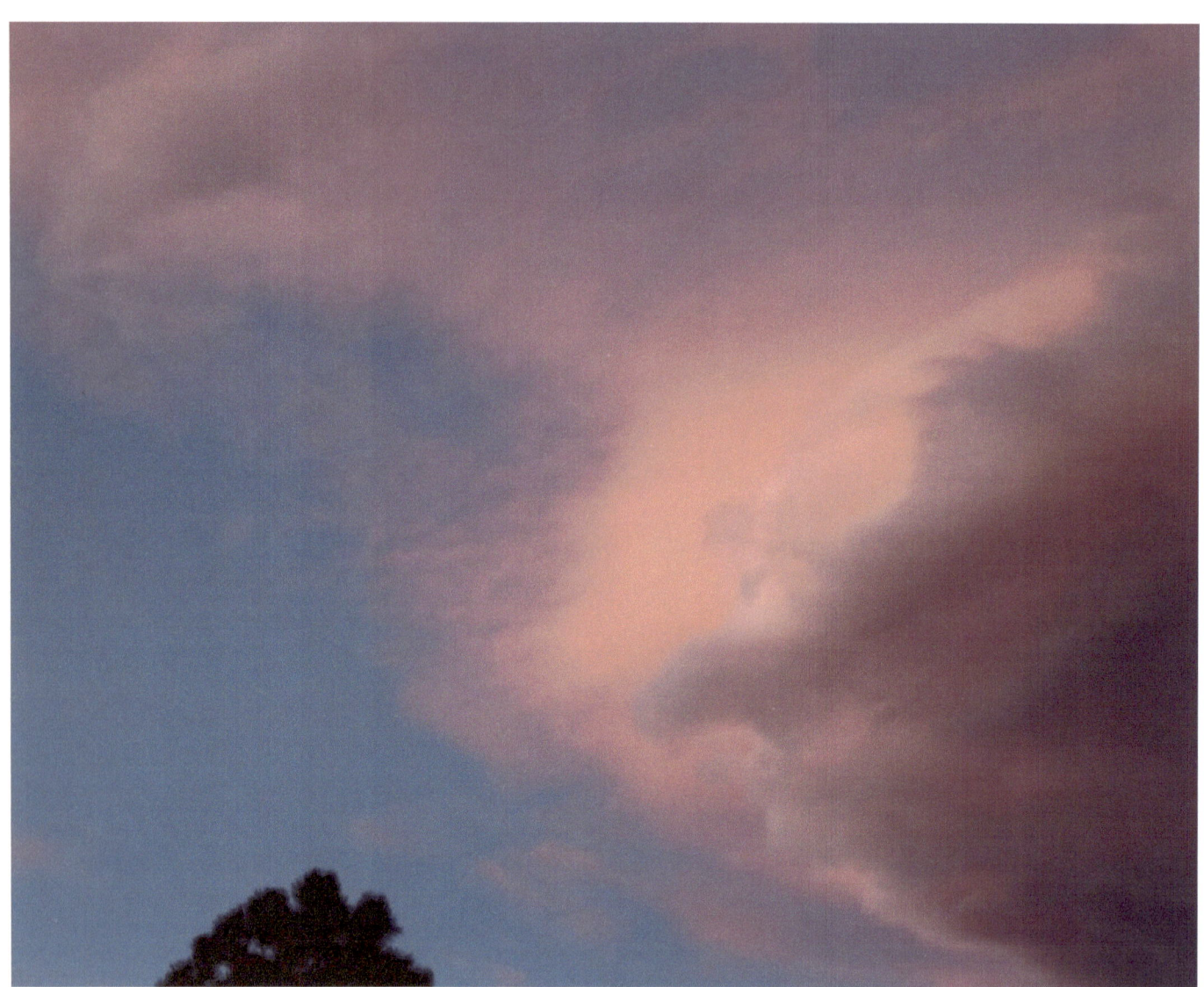

He was
there
For a
Moment

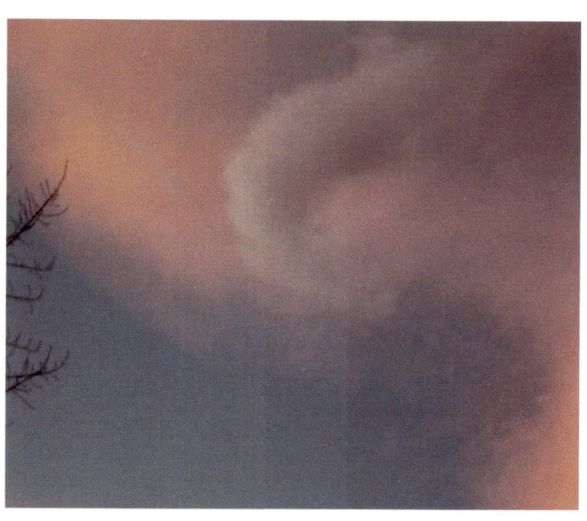

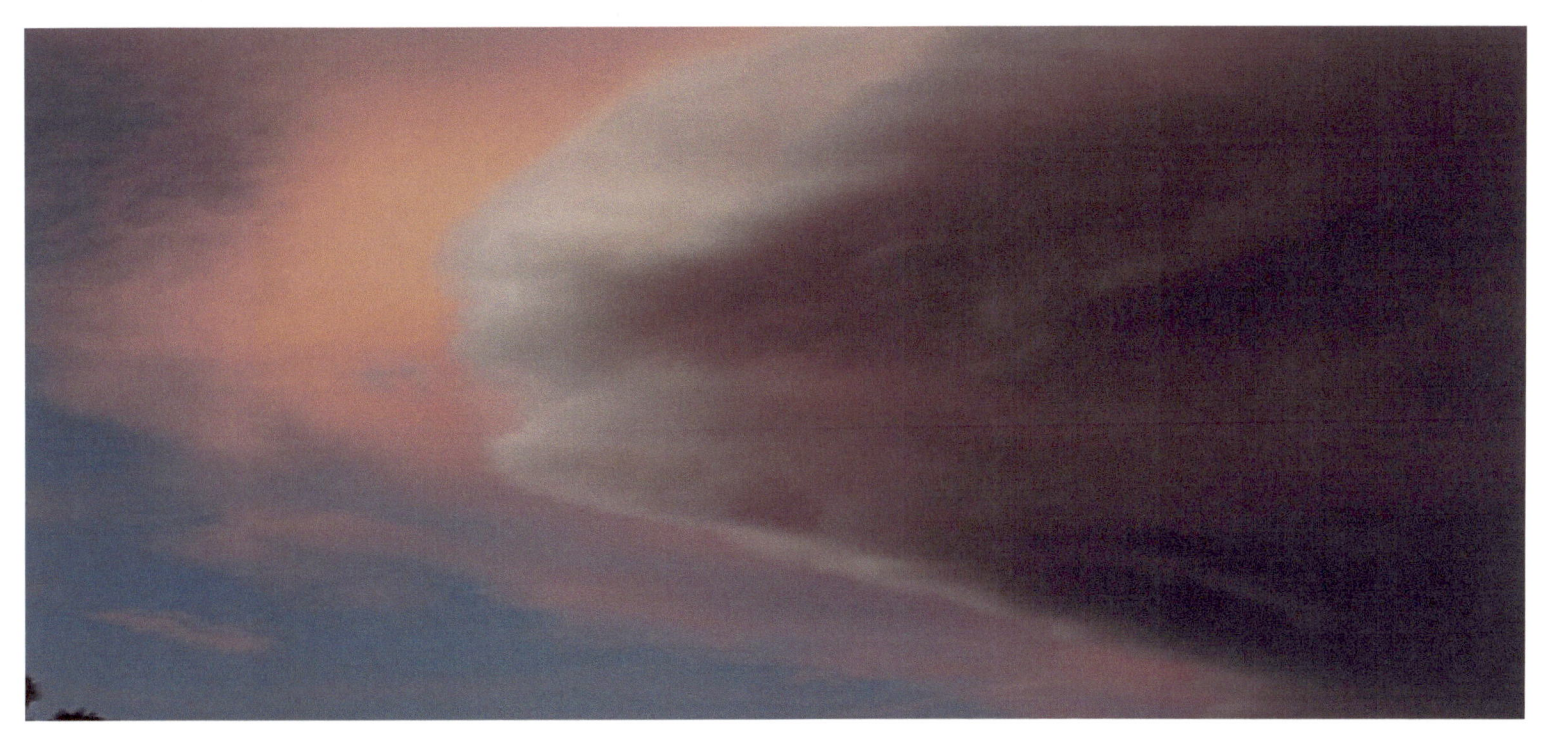

AND THEN HE WAS GONE.

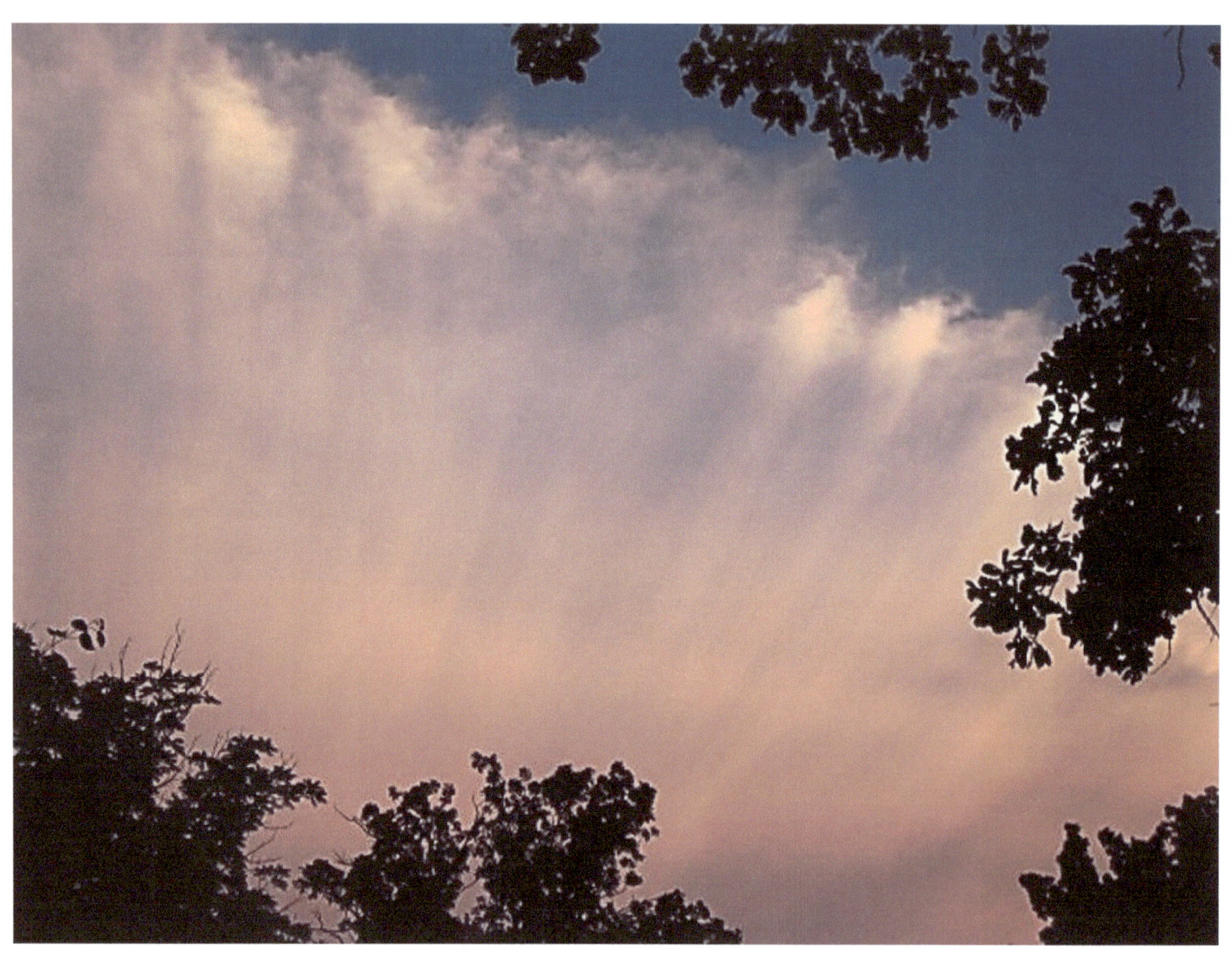

Ballerina cloud

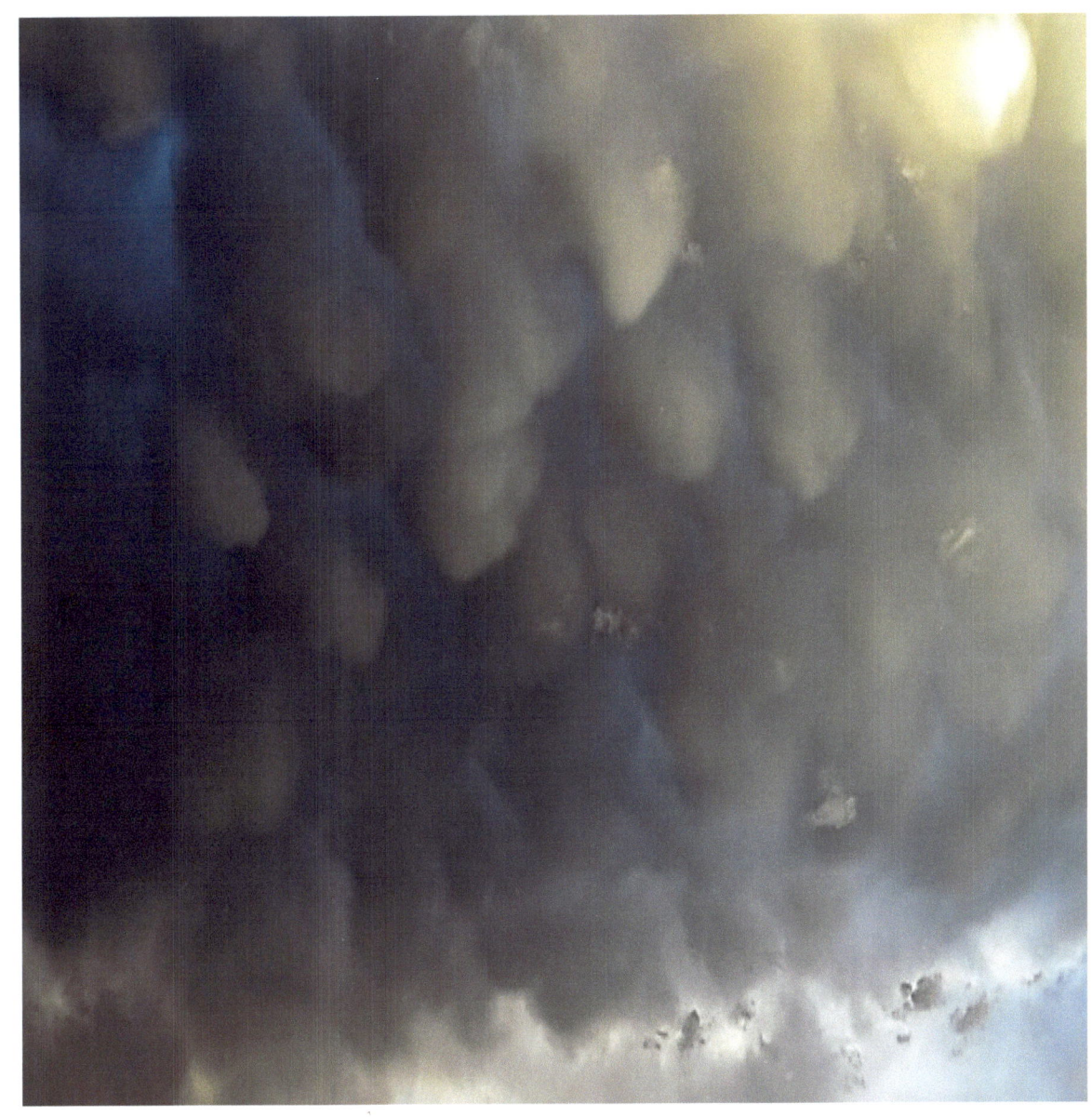

Succulents

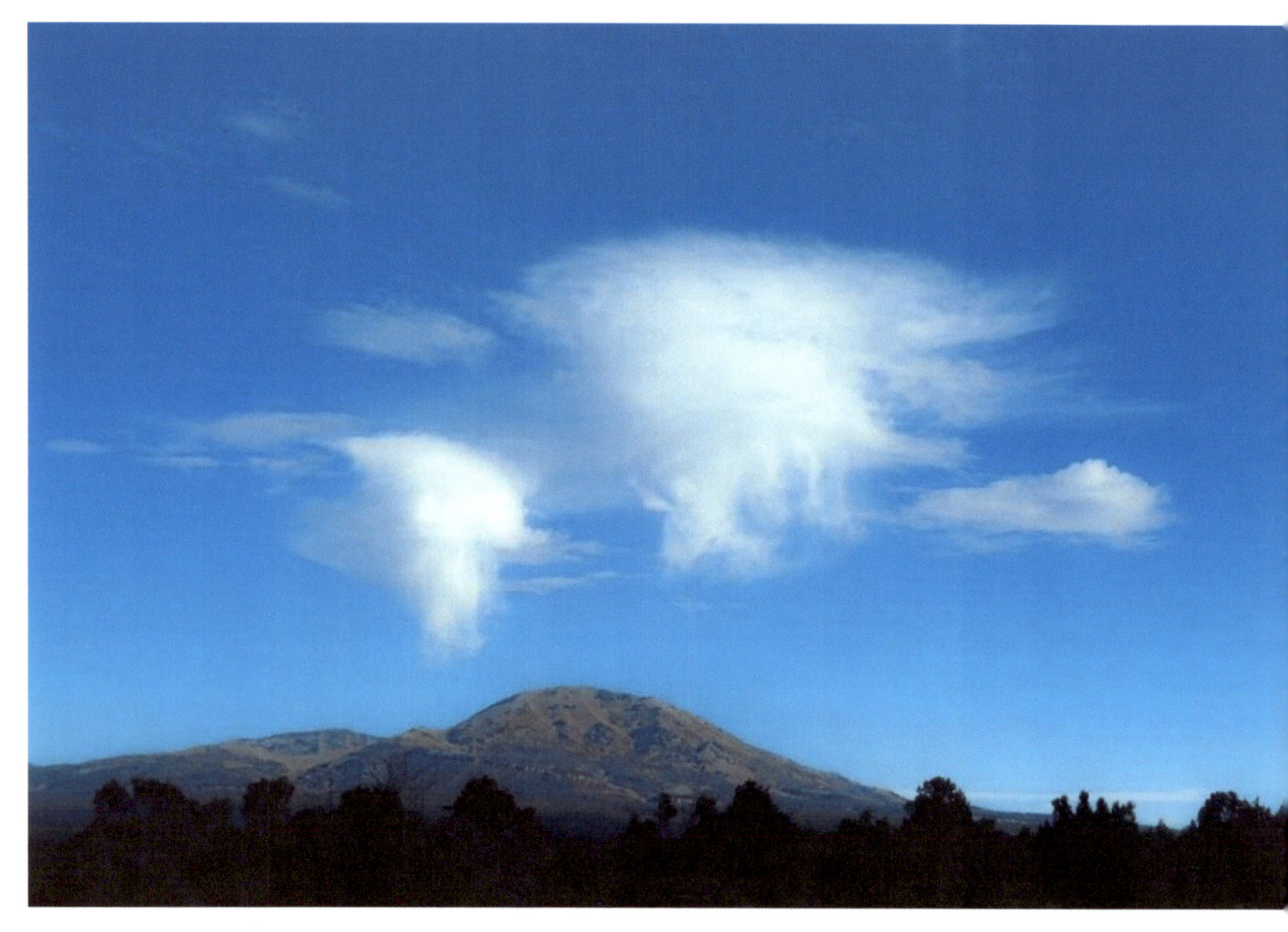

Geese on my mind.

Here we have
a polar bear
hunting walrus.

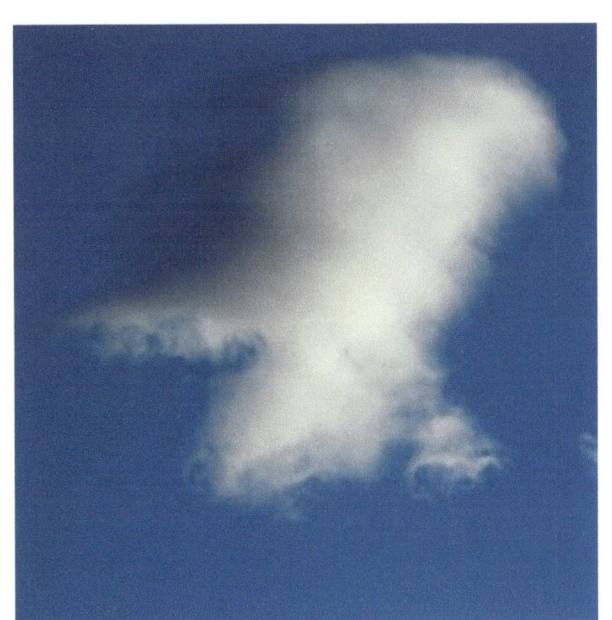

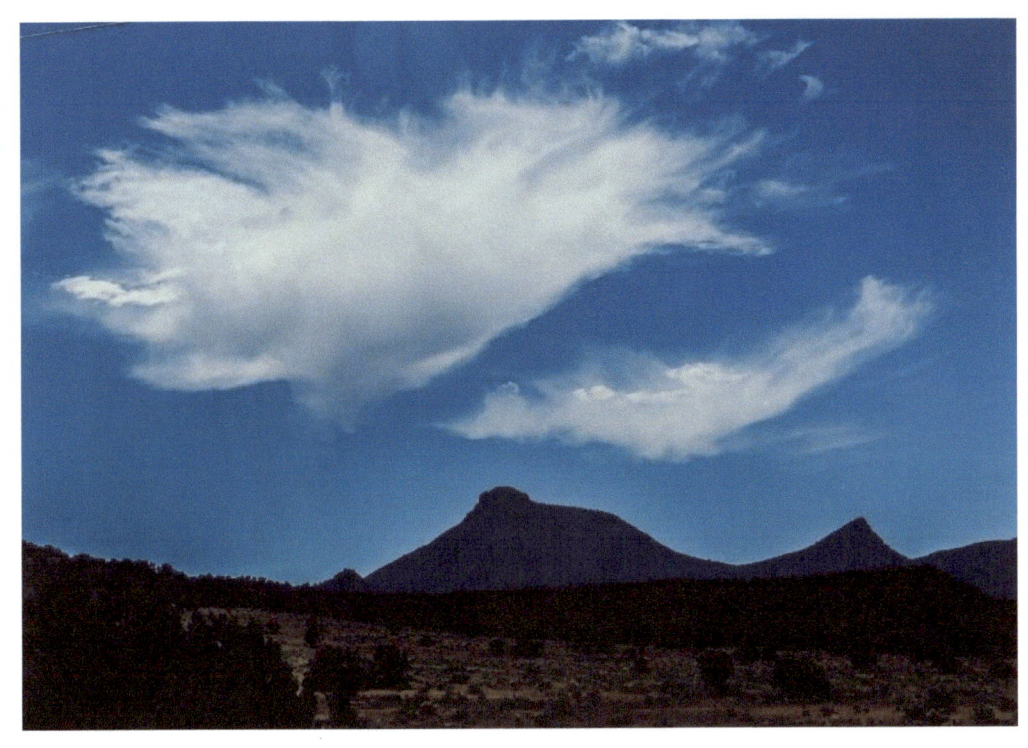

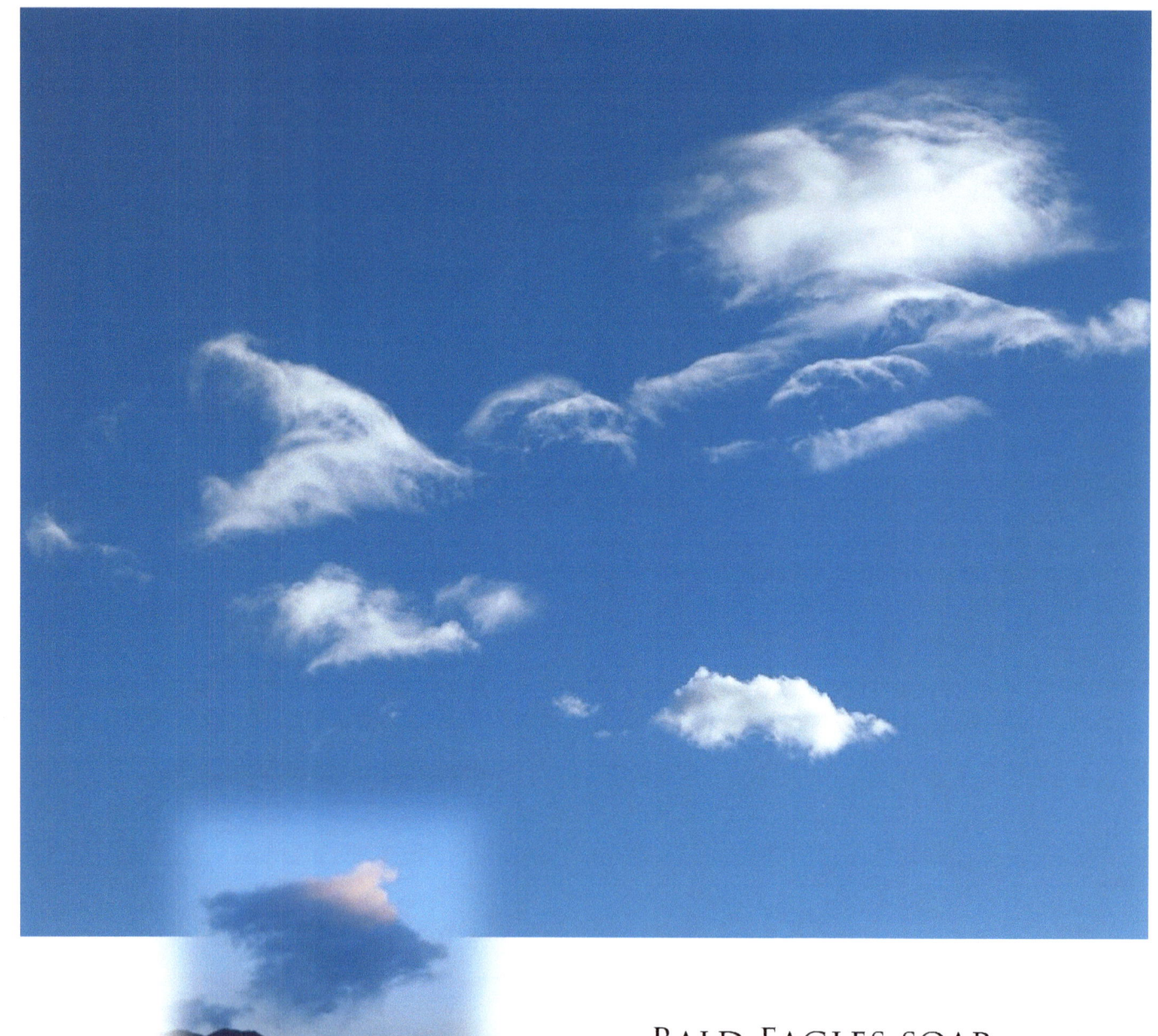

Bald Eagles soar

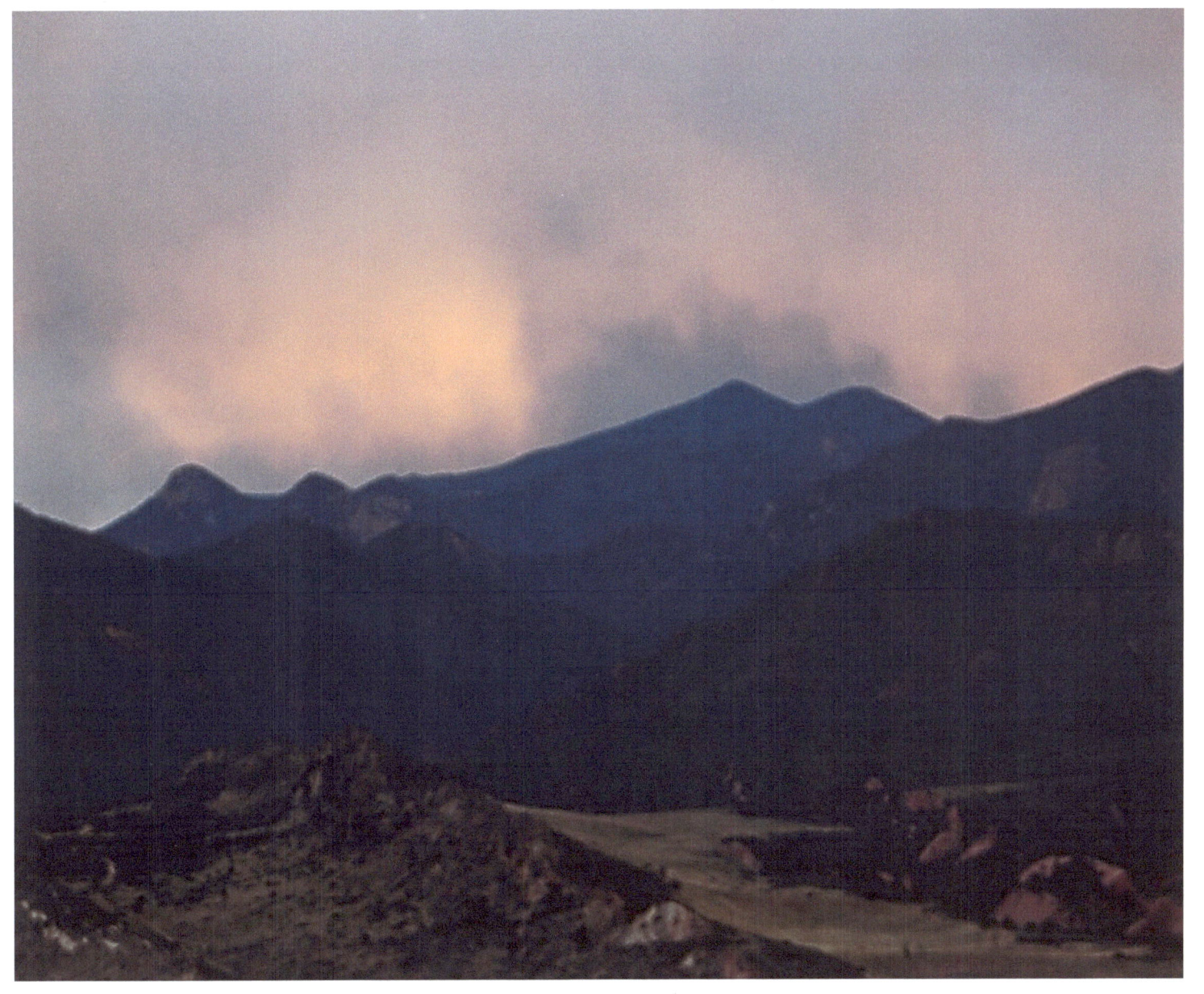

First Light

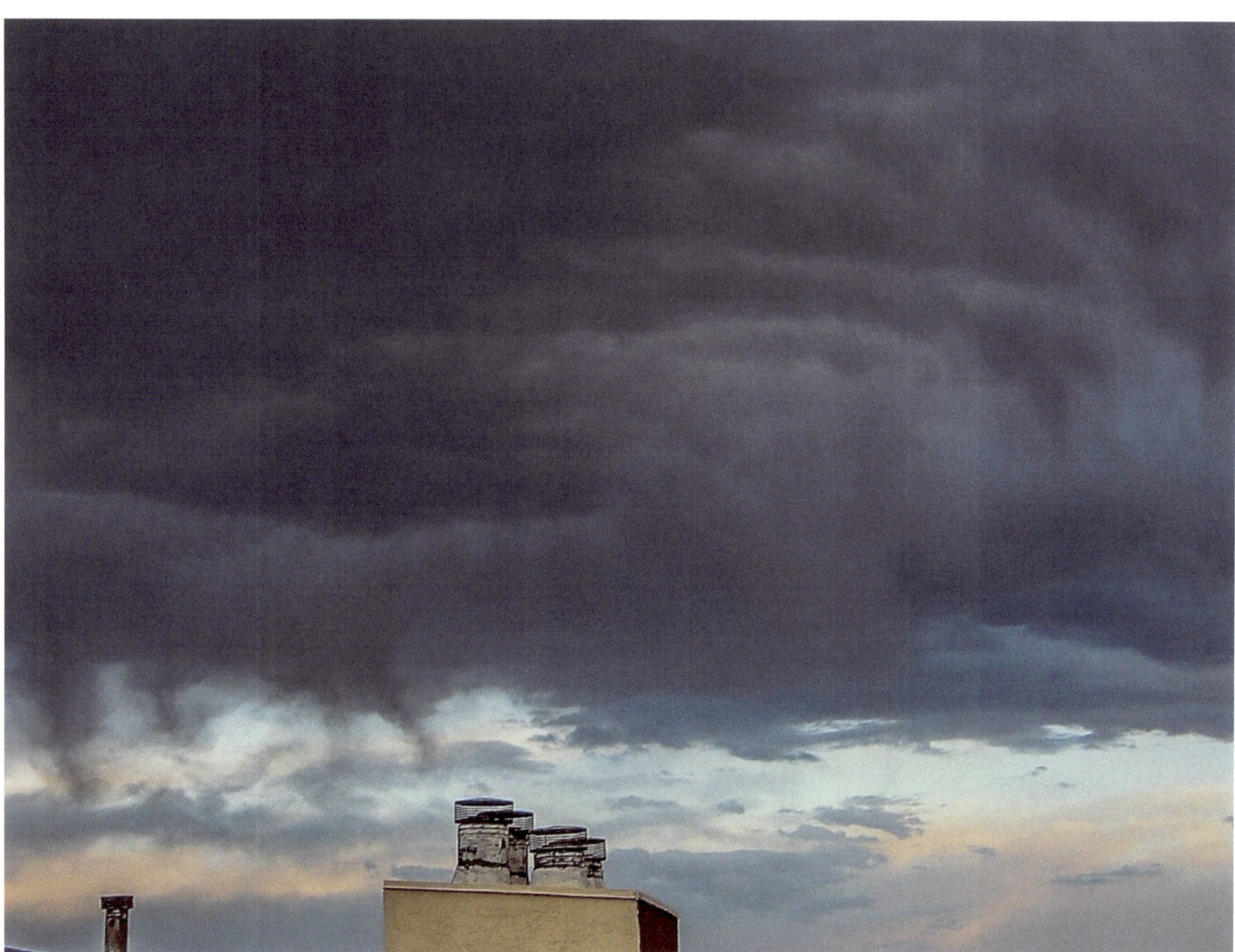

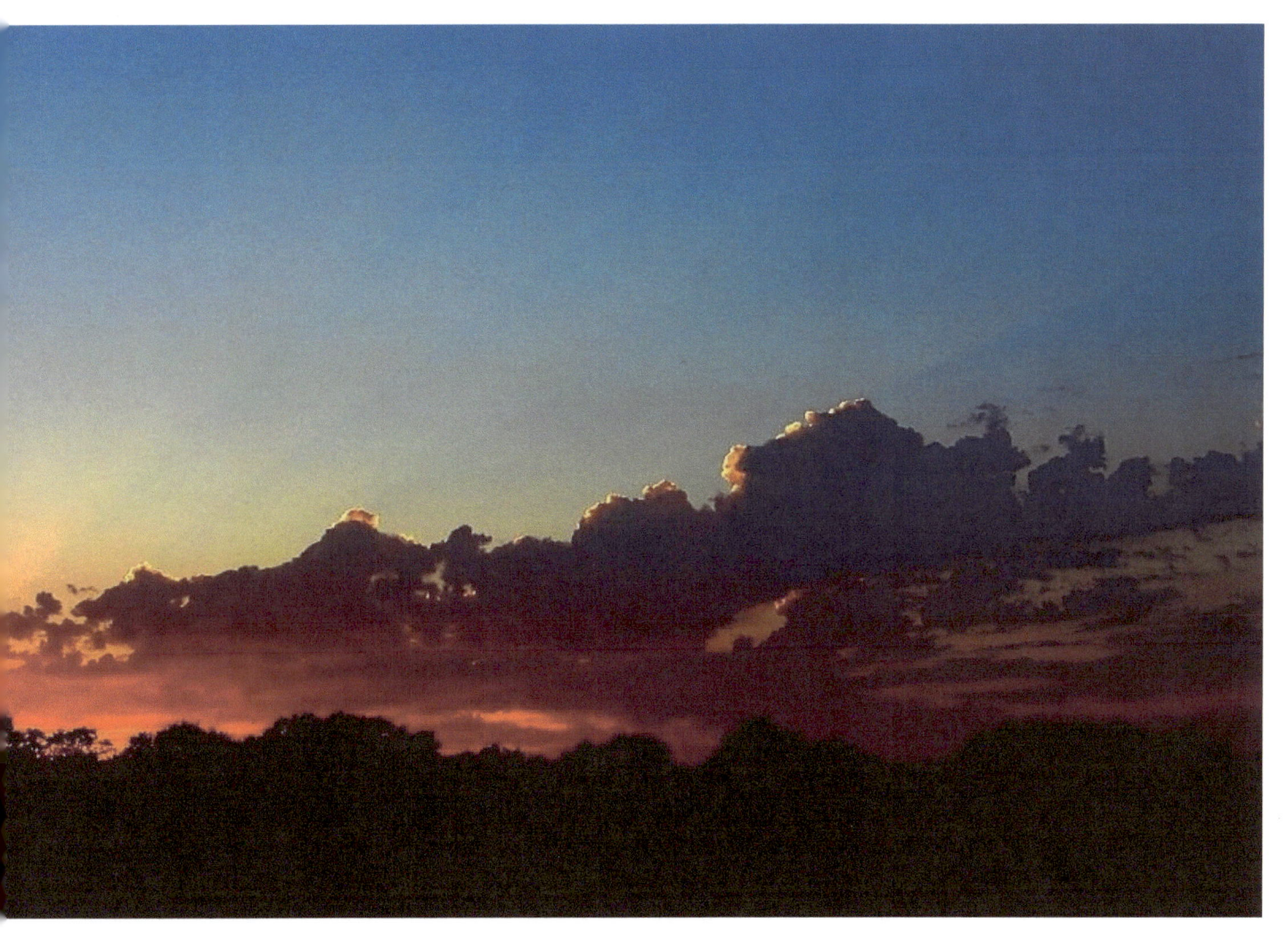

Then day turns to Night.

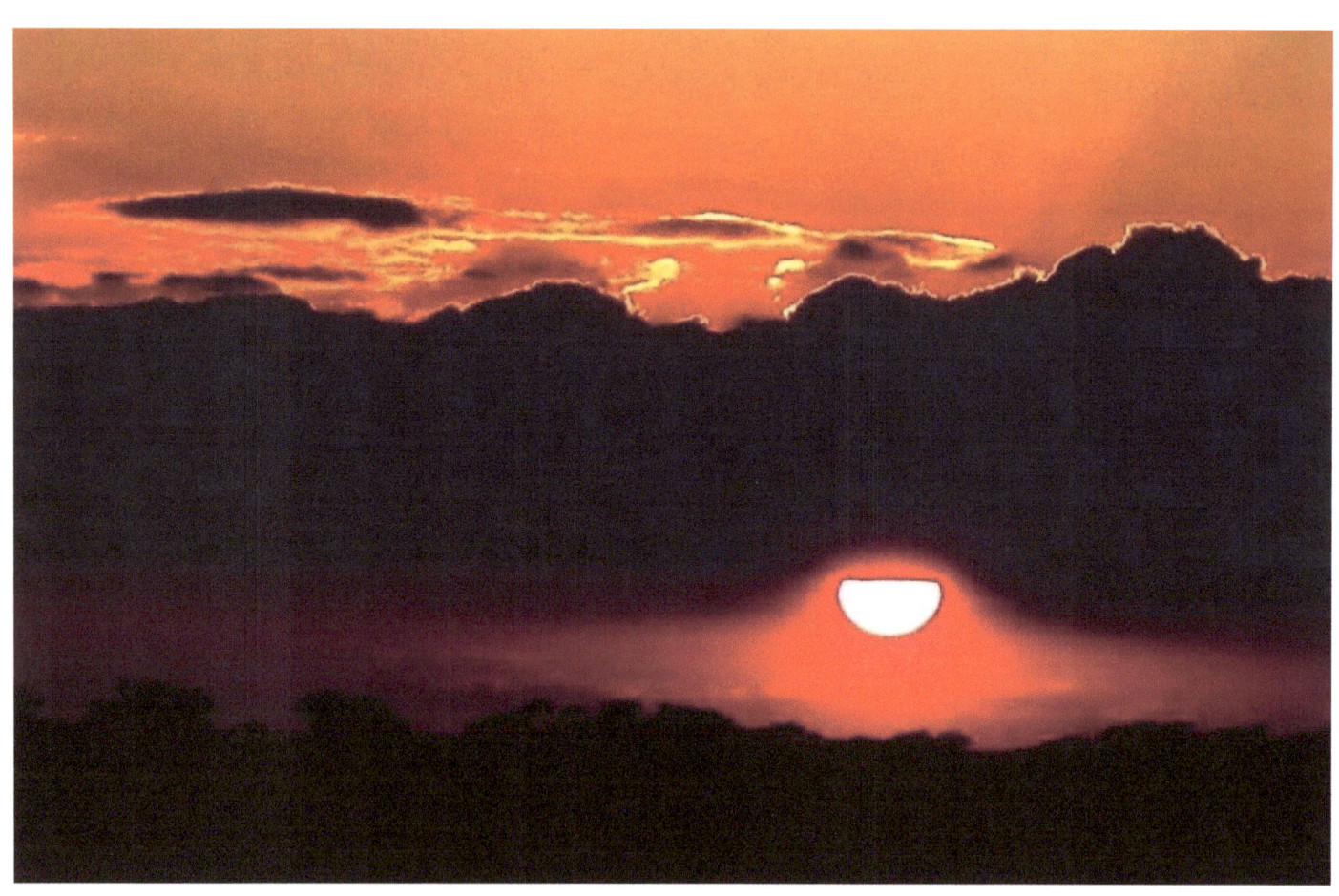

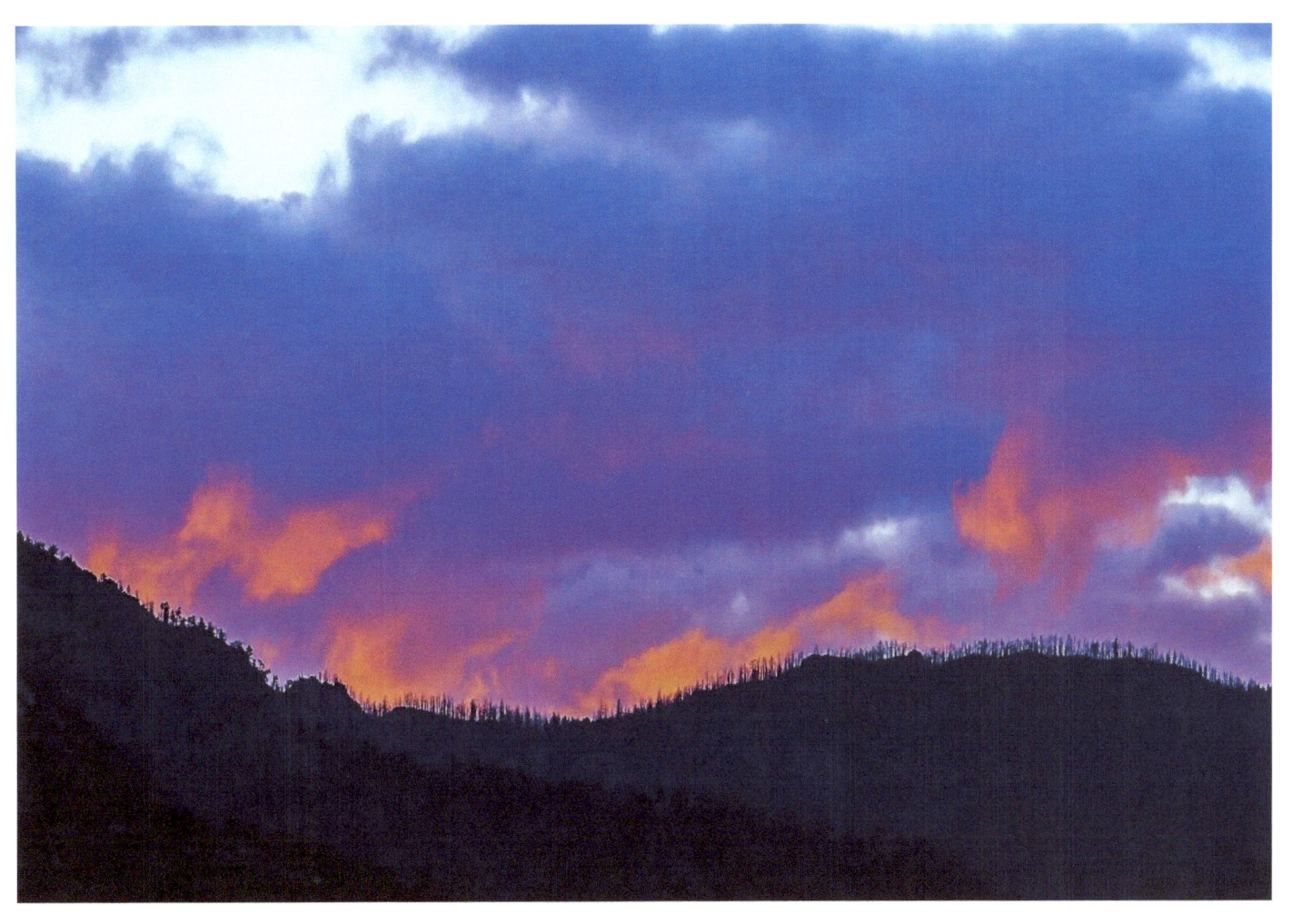

Startling clouds leap over the ridge

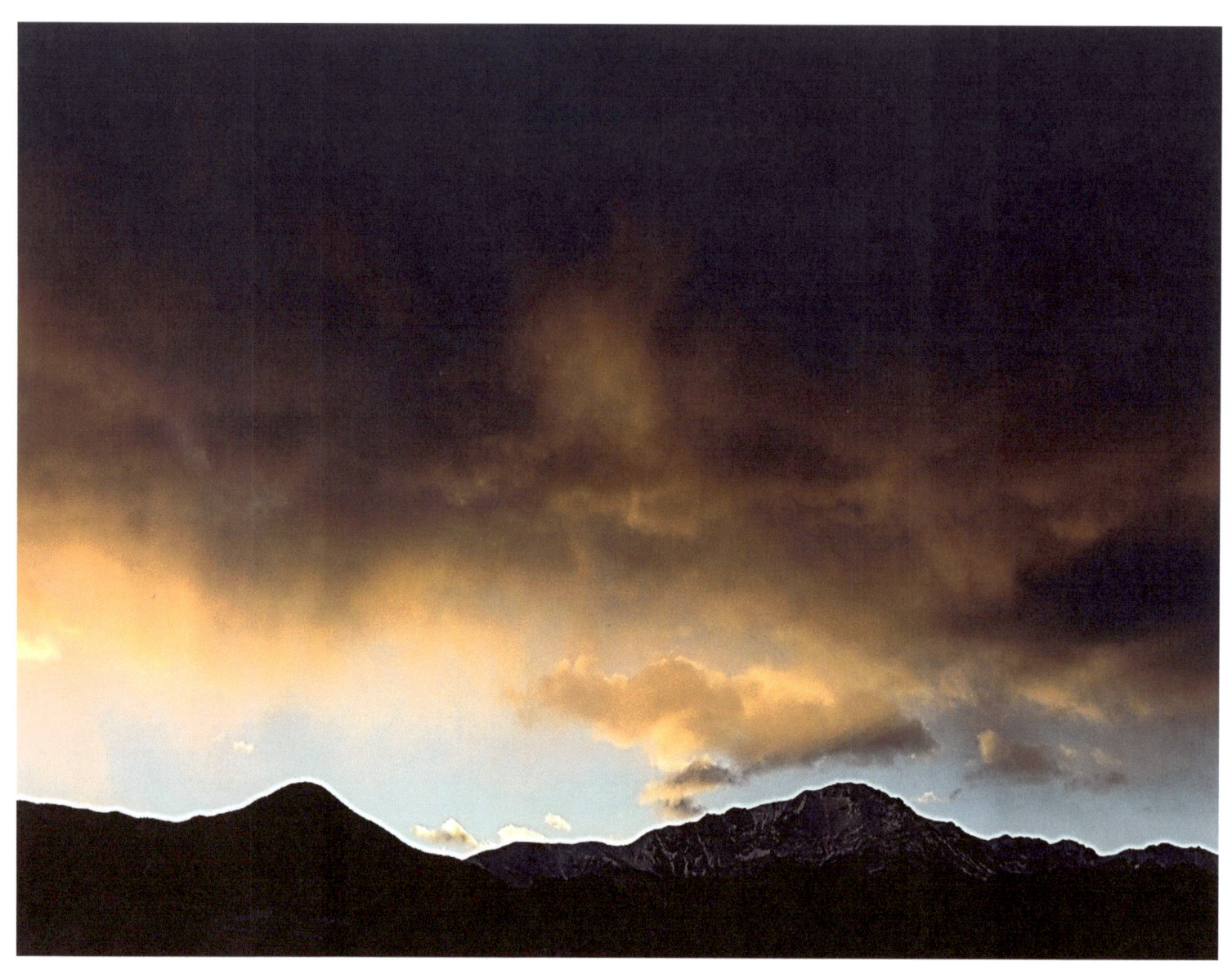

OR BUBBLE UP FROM THE MOUNTAIN.

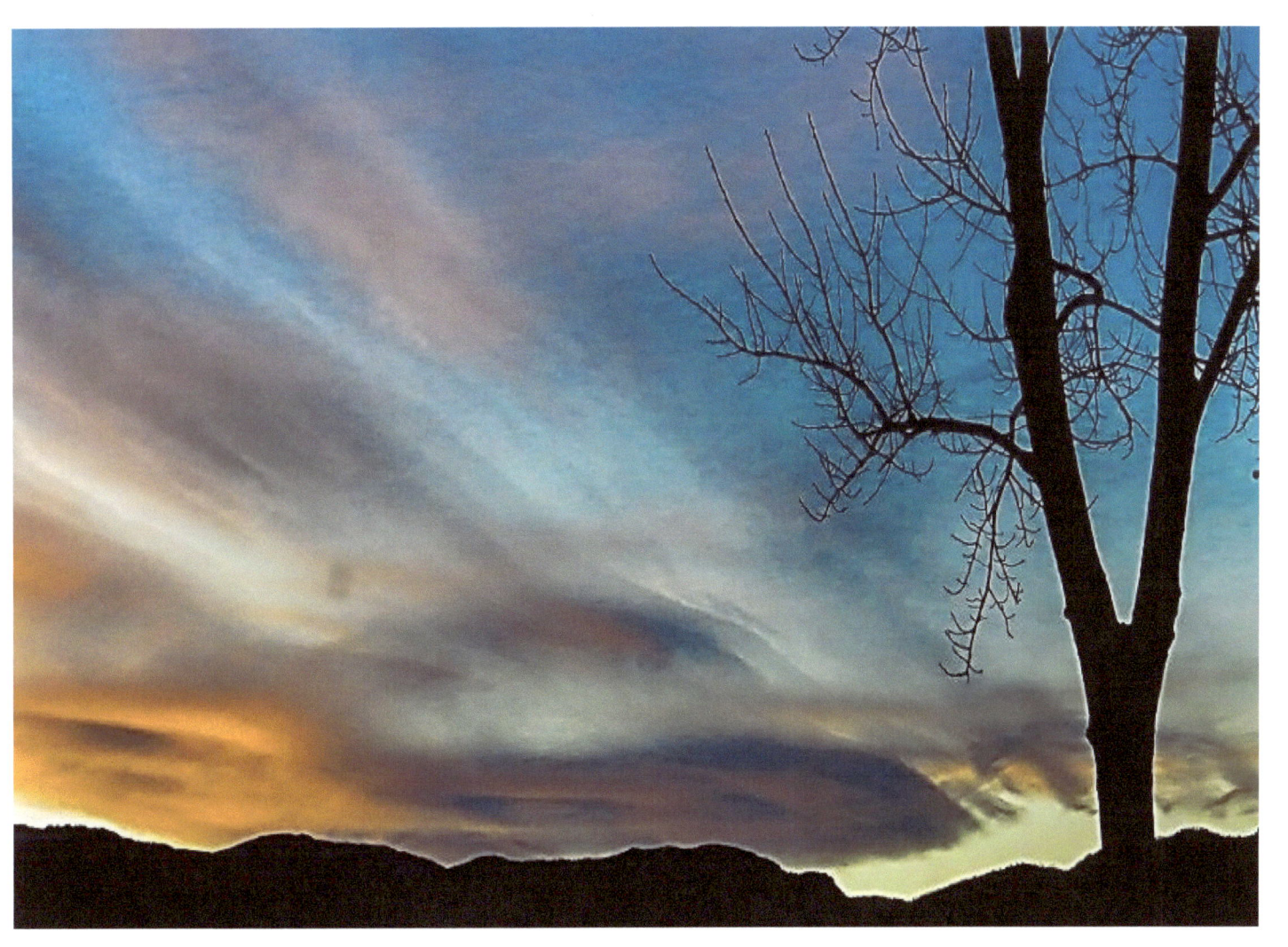

THERE IS SUCH BEAUTY

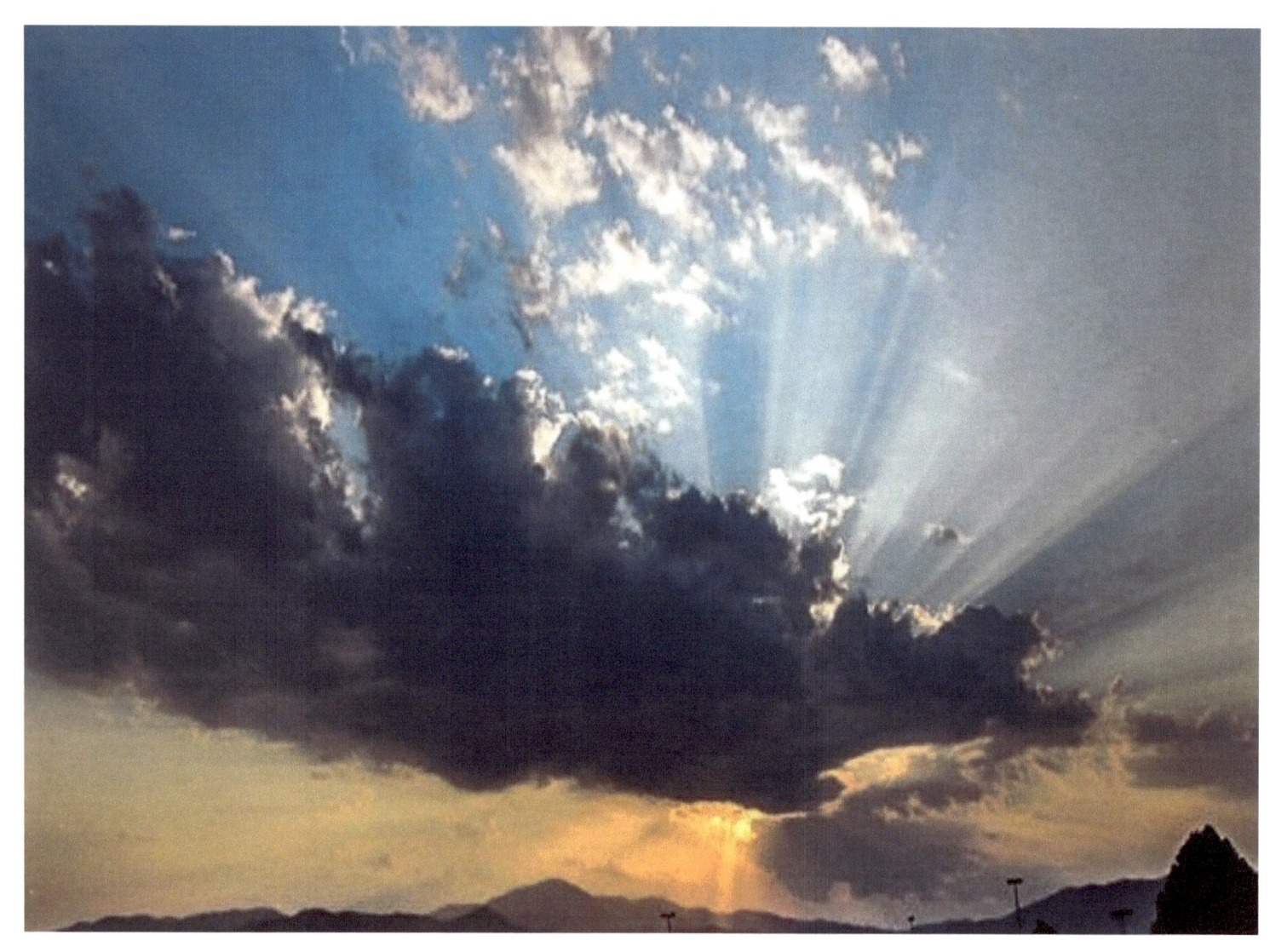

such Glory

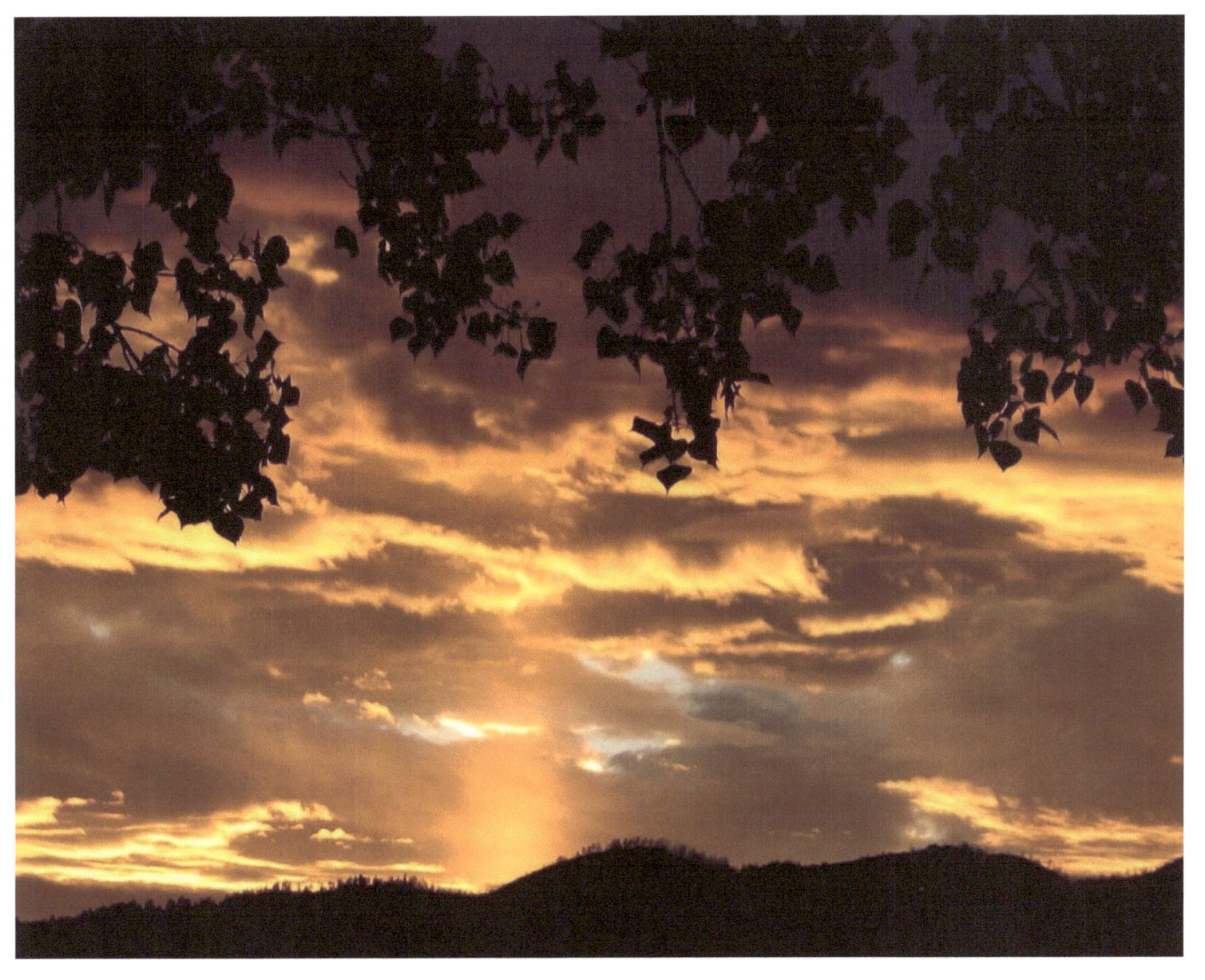

as Clouds combine with Light

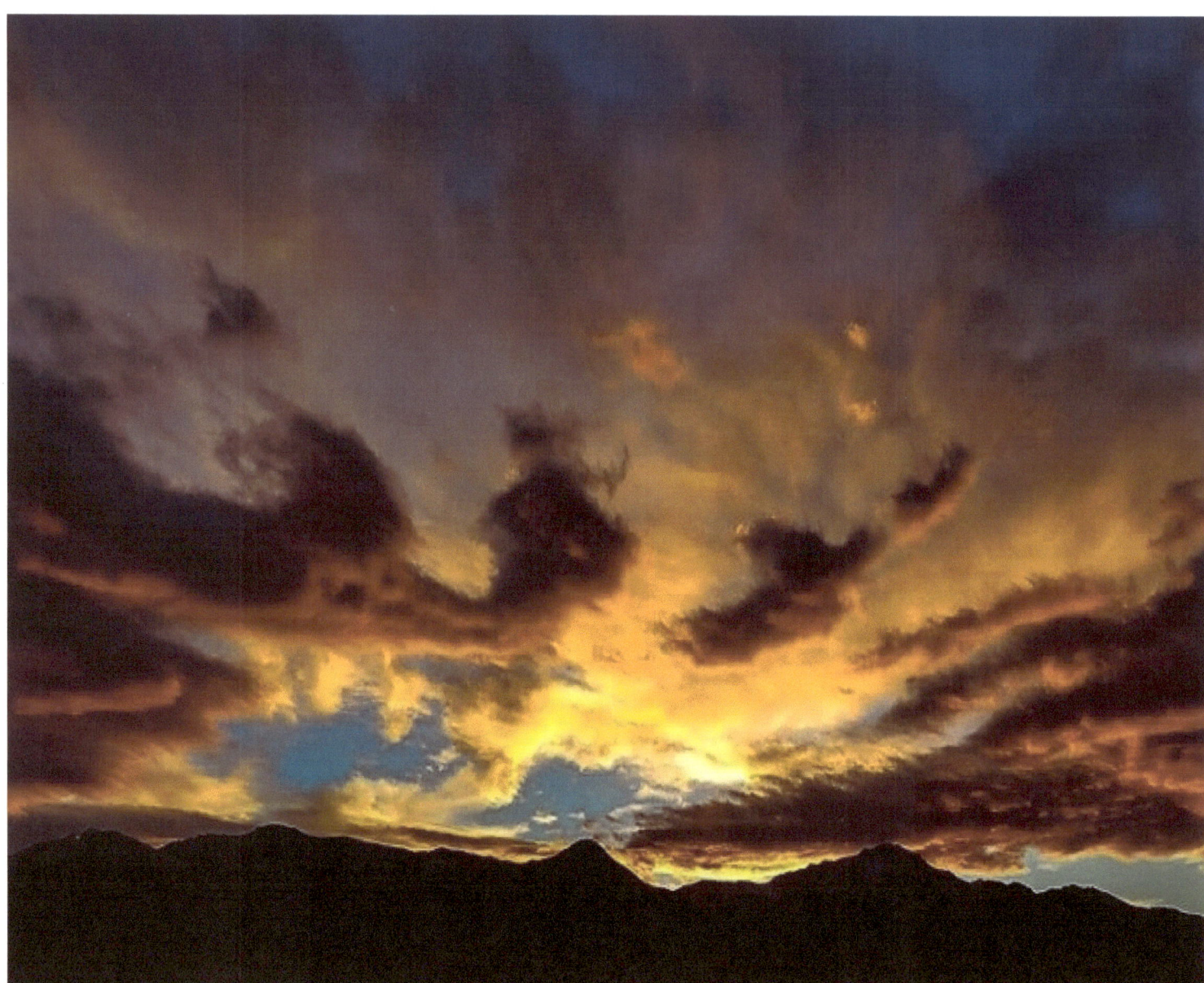

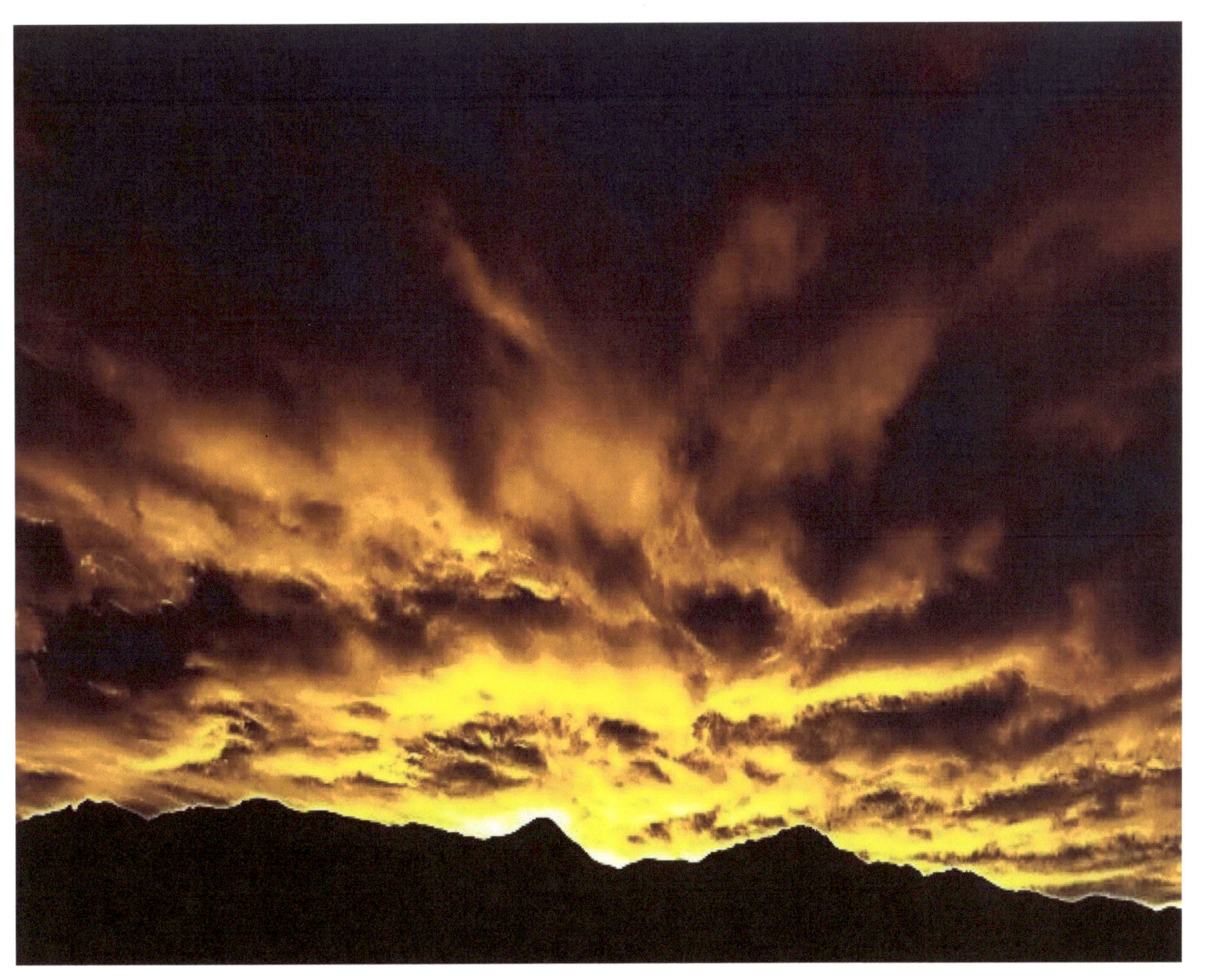

TO USHER IN THE NIGHT.

Echo Hill Arts
is pleased to make a new line of
## Images from Atwood
## Photographic Diversions for Areas of Waiting

available Print on Demand
through **Amazon.com** and **CreateSpace Direct**

Echo Hill Arts Press

www.ingramcontent.com/pod-product-compliance
Lightning Source LLC
Chambersburg PA
CBHW042025200526
45172CB00028B/1120